POSTCARD HISTORY SERIES

Georgetown and the Waccamaw Neck

IN VINTAGE POSTCARDS

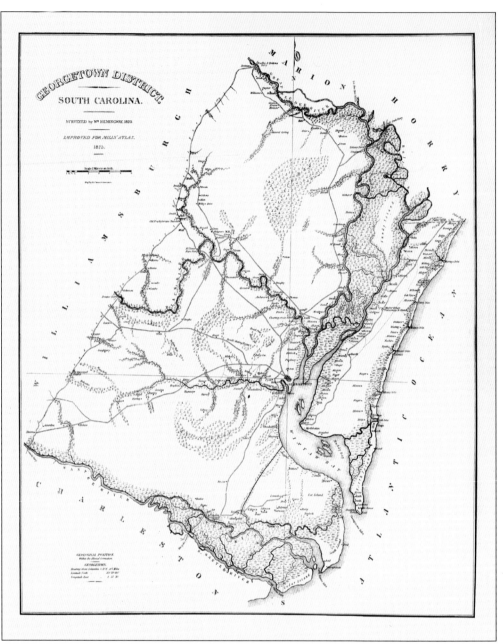

This map of Georgetown District, drawn by surveyor William Hemingway in 1820 and improved for Robert Mills' 1825 *Atlas of the State of South Carolina,* defines the geographic area that is now Georgetown County. Robert Mills was the state engineer when he compiled the atlas in which he wrote, "The inhabitants of Georgetown, and its vicinity, have a delightful and salubrious retreat in the sickly season, on North Island, and the adjacent sea islands. A happier situation is not to be found anywhere; for here the perpetual breezes and saline vapours are constantly rising from the ocean. Three hours brings the citizens from the town to the sea. The good things of this life are here really enjoyed by the inhabitants in abundance; for the land and the ocean lay treasures at their feet."

POSTCARD HISTORY SERIES

Georgetown and the Waccamaw Neck

IN VINTAGE POSTCARDS

Susan Hoffer McMillan

ARCADIA
PUBLISHING

Published by Arcadia Publishing
Charleston SC, Chicago IL, Portsmouth NH, San Francisco CA

Printed in the United States of America

Library of Congress Catalog Card Number: 2002115596

For all general information contact Arcadia Publishing at:
Telephone 843-853-2070
Fax 843-853-0044
E-mail sales@arcadiapublishing.com
For customer service and orders:
Toll-Free 1-888-313-2665

Visit us on the Internet at www.arcadiapublishing.com

For Marshall, who cooked and cooked and cooked....

ON THE COVER
This early 20th-century image, beside the Front Street location of Bank of Georgetown, includes one man recognized in an earlier photograph of the bank's officers. When considering this, and contrasting the men's business attire and demeanor with the ox cart, one assumes that this picture was staged. Note the youths, far left, watching the photographer. (Courtesy of Ed Carter.)

CONTENTS

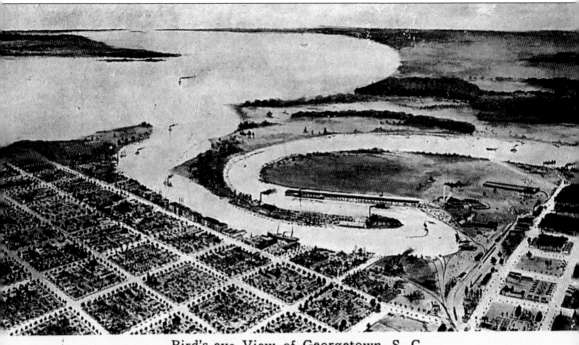

Bird's-eye View of Georgetown, S. C.

Painted in 1901 by artist Harper Bond, this overview of Georgetown was one of two paintings commissioned by city officials for Georgetown's celebrated booth at the South Carolina Interstate and West Indian Exposition, or the Charleston Exposition, lasting from December 1, 1901 to June 1, 1902. Surprisingly accurate to have been painted without the benefit of an aerial perspective, this oil painting now hangs in Georgetown's City Hall. The trees outlining each city block were among 2,000 trees planted during Mayor William D. Morgan's administration. A companion painting of Atlantic Coast Lumber Corporation's "new town," west of the city, was lost years ago.

ACKNOWLEDGMENTS

This book was accomplished with the help of many individuals who shared postcard images, information, and valuable time to assist the author in this endeavor. Special thanks go to the following people and organizations: Gene Anderson; Blake Arp of Burroughs and Chapin Company; Trudy Bazemore of Georgetown County Public Library; Davie Beard of S.C. Postcard Collectors' Club; Raejean Beattie of Hopsewee Plantation; Bill Benton; Bud Black; John Bracken; Lee Brockington of Belle W. Baruch Institute; Ed Carter; Annette Coles; Nell Cribb of Miss Nell's Tours; Pat Doyle of Georgetown County Historical Society; Wes Dunson; Jim Fitch and Zella Wilt of The Rice Museum; George Fogel; Laurie Frueauf and Shanika Stafford of Georgetown County Chamber of Commerce; Debra Gust of Lake County (IL) Discovery Museum, Curt Teich Postcard Archives; Mabel Hamilton; Bud Hill and Emily Baldwin of The Village Museum; Robert Hinely; John LaBruce; Arthur H. " Doc" Lachicotte Jr.; Katrina Lawrimore of Kaminski House Museum; Katie Maleckar of Prince George Frame Shop; Frances Gilleland of Andrews Old Town Hall Museum; Alberta Lachicotte Quattlebaum; John Sands of Brookgreen Gardens; Ken Vinson; and Gene Young of Belin United Methodist Church. Once again, Laura D. New, acquisitions editor at Arcadia Publishing, gave valuable assistance, and my family gave the greatest measure of support, which was most appreciated.

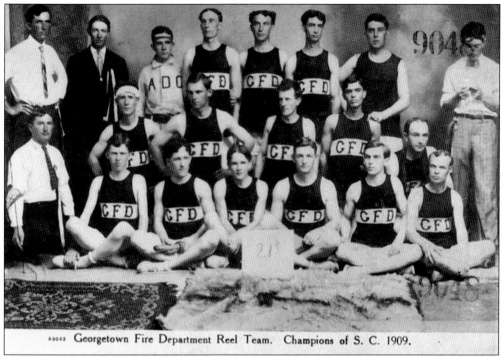

A9048 Georgetown Fire Department Reel Team. Champions of S. C. 1909.

It is the residents who make Georgetown an inviting city, and these members of the George-town Fire Department Reel Team are classic examples. This 1911 postcard proclaims them "state champions in 1909;" the type of competition is unfamiliar, but one assumes it involved other fire companies in South Carolina. Traditionally volunteers, Georgetown's firefighters showcased their skills and equipment on Fireman's Day, an annual celebration featured on page 21. (Courtesy of Curt Teich Postcard Archives.)

INTRODUCTION

The history of Georgetown, South Carolina's third oldest city, revolves around its waterways. Water has provided the area convenient transportation and abundant food sources from its earliest habita-tion by Native Americans 10,000 years ago. Twenty miles of nearby beaches offer ocean access while four rivers, the Pee Dee, Black, Waccamaw, and Sampit, and the nearby North and South Santee Rivers, combine 1,000 miles of riverine access to Georgetown, South Carolina's second larg-est maritime port. The Intracoastal Waterway is the newest connection among these waters. Histori-cal reports of San Miguel de Gualdape, the first Spanish settlement of North America in 1526, often attribute it to the North shores of Winyah Bay, although physical evidence is unproven. Convenient water access attracted Georgetown's earliest permanent settlers before around 1730 when Elisha Screven laid out the town beside the Sampit River adjoining Winyah Bay. Two years later, George-town became an official customs port. First called George Town, it was named for England's King George II. The original town plan now constitutes the city's historic district, listed on the National Register of Historic Places. The Georgetown area has experienced numerous jurisdictional changes, beginning with its designation as part of Craven County sometime after 1682, and ending in 1868 with the present Georgetown County dimensions. Judicial authority was vested in Georgetown District in 1769, shortly before the American Revolution.

From 1730 to 1860, rice supported Georgetown's economy, as area tidelands were steadily cultivated to yield a harvest of unimaginable wealth for enterprising planters of European heritage who embraced slavery to develop vast plantations. Indigo surpassed rice as the staple crop before the American Revolution, after which rice was king until the Civil War. The resulting aristocratic society of "rice princes" drew state and national attention, including political clout for privileged planters and others. Joseph Alston, Robert F.W. Allston, Washington Allston, Thomas Lynch Sr., Thomas Lynch Jr., Eliza Lucas Pinckney, Joel Poinsett, Joshua John Ward, and Plowden C.J. Weston were among area names written in history books. This affluence declined during the Civil War, and any hope of recovering the antebellum lifestyle ended when late 19th-century hurricanes destroyed rice impoundments built with slave labor. Also, many rice workers found higher paying jobs in the growing lumber industry. Union gunboats blockaded Winyah Bay during most of the Civil War, but Georgetown escaped with considerably less damage than suffered in the American Revolution, when the town was shelled. At the close of the Civil War, Gen. William T. Sherman punished the South, which included burning Chesterfield, where many of Georgetown's governmental records were hidden from Federal troops. The resulting gap in documentation continues to frustrate legal and historical researchers.

Saw mills replaced rice mills in the late 19th century, and Georgetown entered a new century hopeful of economic renewal. Harbor improvements and rail service expanded Georgetown's trade routes, while electricity, water, and sewer improved living conditions. Timber production soon surpassed cotton, rice, fishing, and naval stores as Georgetown's new economic strength, led by Atlantic Coast Lumber Corporation. The city was bustling by 1903 when A.C.L. invested $1,000,000, building what became the East Coast's largest lumber operation, with a supporting mill town west of the city and its Sampit River bend. A few vintage mill houses remain today, the last vestiges of that "new town." Progress halted with the Great Depression in 1929; three banks failed in Georgetown, and Atlantic Coast Lumber closed in 1932. Losses were only slightly mitigated by wealthy Northern investors who purchased bankrupt plantations, refurbishing them as winter hunting retreats. In 1937, International Paper Company opened a Southern Kraft Paper Mill in Georgetown. Expansions of that mill continue its economic significance; I.P.C. is now the county's largest landowner. However, prevailing poverty allowed many historic structures to survive unaltered because few residents could afford to remodel existing buildings. Now carefully restored, these properties are the pride of Georgetown. Today, the city boasts over 30 18th-century homes, more than Colonial Williamsburg. Georgetown Steel Corporation was formed in 1970 and remains the newest major industrial addition to Georgetown. Tourism is Georgetown County's largest employer.

One of the oldest resort areas on the East Coast, the Waccamaw Neck is a 20-mile-long peninsula extending from Georgetown County's northern border south to Winyah Bay, bordered on the east by the Atlantic Ocean and on the west by the Waccamaw River. It is considered the southern portion of the Grand Strand, the greater Myrtle Beach area. The "neck" once had more than 50 plantations, many with land grant deeds extending from the river to the ocean. President George Washington visited here, and in Georgetown, during his 1791 Southern tour. Planters sought annual refuge at North Island, Pawleys Island, Magnolia (now Litchfield) Beach, Dubordieu (now DeBordieu) Beach, and Murrells Inlet. Popularity of the coast stemmed from the ocean breezes and the absence of malaria-carrying Anopheles mosquitoes. Planters learned to avoid deadly "summer fevers" by moving their families to the beach during the growing season. Slaves remained on plantations surrounded by rice fields, because most African Americans are genetically resistant to malaria. Ghost lore and mysteries arising from 19th-century Waccamaw Neck remain intriguing; Pawleys Island has its Gray Man, roaming the beach to warn of impending storms, Brookgreen Gardens has the mysterious disappearance at sea of Theodosia Burr Alston, and Murrells Inlet has Alice's Ghost, searching for her lost engagement ring.

The Santee River flows 143 miles from the confluence of the Wateree and Congaree Rivers to the Atlantic Ocean. Its coastal portion, divided into the North and South Santee Rivers, is the area featured in this book. It forms one of South Carolina's largest tidal deltas, over two miles

wide. French Huguenots were the first European settlers on the South Santee River, and the area became known as French Santee. It was on the North Santee River that Jonathan Lucas, who revolutionized rice production by developing the water-powered rice mill, was born. With few commercial resources nearby, residents of these areas eagerly sought connections in Georgetown and Charleston. The 11-mile distance from Georgetown's Sampit River to the North Santee ferry landing was a two-rut road until 1927, when it was surfaced with sand clay and became part of Route 40, the Ocean Highway. The Santee Rivers were bridged by 1935.

Images in this book focus on the first half of the 20th century. Accompanying historical texts were derived from oral interviews and numerous books documenting the area's past, most notably *The History of Georgetown County* by George C. Rogers Jr. and taught by Pat Doyle, and publications of Georgetown County Historical Society, Georgetown County Public Library, and The Rice Museum. Postcards were collected over a five-year period by the author and supplemented with images borrowed from museums and loaned by several generous collectors. In some cases, postcard sizes have been manipulated to accommodate the book's layout. A few antique stereoviews of the area are also included in this pictorial history. Hopefully, colorful postal mailing cards will not succumb to advances in electronic communication. Often focusing on the ordinary, vintage postcards provide a window into the past that doesn't seem to exist elsewhere. Curt Teich Postcard Company, once a leading U.S. publisher of postcards, had a promotional slogan, "Why write a letter when postcards say it better?" Deltiologists, better known as postcard collectors, couldn't agree more.

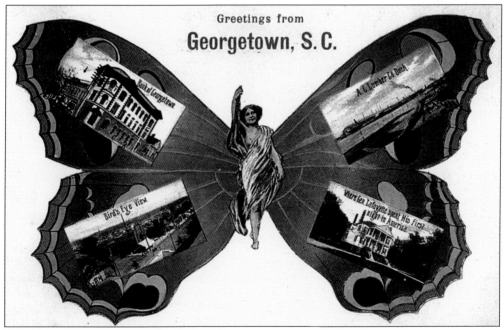

Postmarked 1909, this "Greetings from Georgetown, S.C." card features four miniature representations of postcards seen elsewhere in this book. Starting clockwise, these full-size images can be found on pages 35, 78, 16, and 24. Similar butterfly and flower designs were popular postcard styles a century ago, examples of which exist for numerous cities and towns of yesteryear.

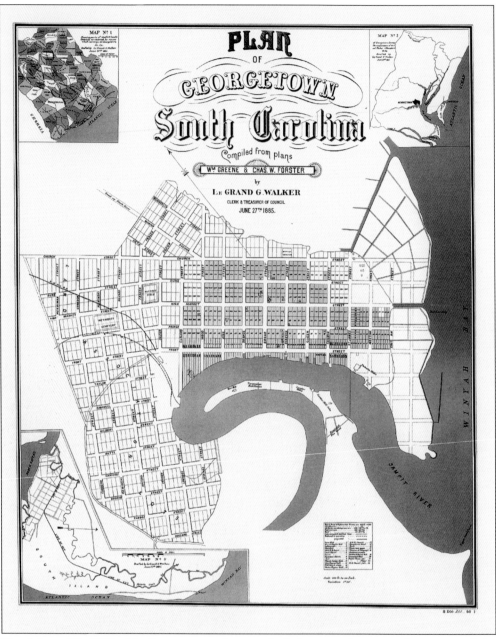

Dated June 27, 1885, this Georgetown city map includes recently annexed property of the Georgetown Land Association, subdivided into lots for planned growth beyond the original city limits. The new area, west of the city and its Sampit River bend, was previously Serenity Plantation, owned by J.B. Pyatt. The land association was a locally held stock company presided over by attorney Richard Dozier. The map was prepared by Le Grand G. Walker, counsel for Atlantic Coast Lumber Corporation and clerk and treasurer of Georgetown city council. Earlier Georgetown maps were drawn around 1730 by Elisha Screven, with surveyor William Swinton, and in 1798 by Charles Brown and Dr. Joseph Blyth, with surveyor John Hardwick. (Courtesy of Prince George Frame Shop.)

One

GEORGETOWN

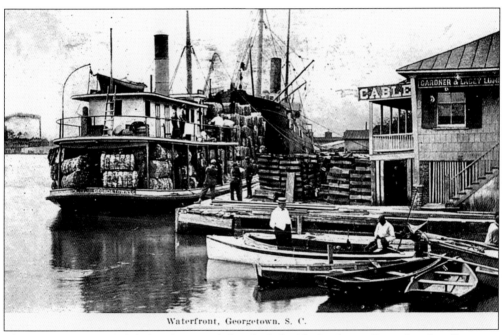

Waterfront, Georgetown, S. C.

The steamer *Brunswick*, laded with cotton bales, docks beside Gardner & Lacey Lumber Company offices adjoining the riverfront wharf at the terminus of Orange Street. Owned by Black River Steamship Company, the *Brunswick* was piloted by Capt. Frank Bellune and Joe Richardson. It was the last steamship to provide regular service to Black River landings from Georgetown to Mingo Bridge Landing. Gardner & Lacey organized in 1892 as a subsidiary of H.H.Gardner & Company of Chicago. Their 15-acre mill operation was on the peninsula across the Sampit River from Georgetown. (Courtesy of Robert Hinely.)

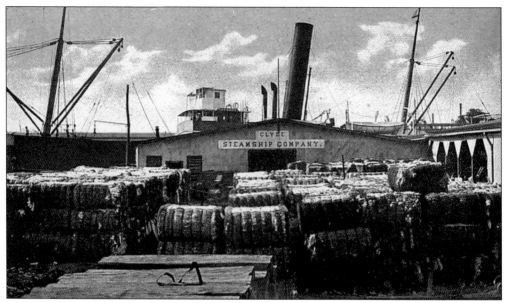

The Clyde Steamship Company warehouse appears dwarfed by a massive cotton shipment stacked on its wharf. The "Clyde" was based at the terminus of King Street near the present Rainey Park, previously the site of the U.S. Naval Reserve building (shown on page 26). Rainey Park was named for Georgetown's native son, Joseph Hayne Rainey, the first African American to serve in the U.S. House of Representatives, from 1870 to 1879.

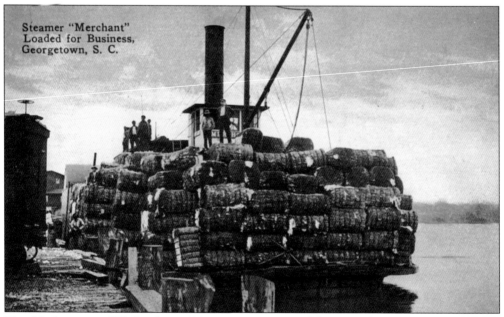

The *Merchant* was a 150-foot long, 430-ton steamer, one of five steamships comprising The Accommodation Line, owned by Ravenel, Holmes, and Company of Charleston. A hundred years ago, the *Merchant* made regular trips carrying freight and passengers between Georgetown and Charleston, with additional stops at landings along the Pee Dee and Santee Rivers. (Courtesy of Curt Teich Postcard Archives.)

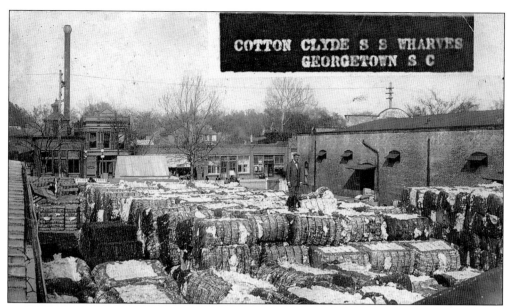

Cotton bales are stacked from Front Street to the Sampit River in this postcard photo taken about 1915. Note the man standing on the bales and the tall Rasheed building in the background. The Clyde Steamship Company was the first ocean steamship company to make regular stops at Georgetown. Based in Bowling Green, New York, with H. Kaminski & Company listed as its local agent, "Clyde" also stopped at Wilmington, North Carolina, and New York. (Courtesy of Bill Benton.)

Barrels commonly used for shipping rice and turpentine are seen on the docks of the Sampit River beside two seated youths enjoying the riverfront activity. This card, postmarked 1909, depicts a typical Georgetown scene a century ago, when waterways were the interstate highways of transportation. Twentieth-century advances often resulted in cheaper ground or air transportation.

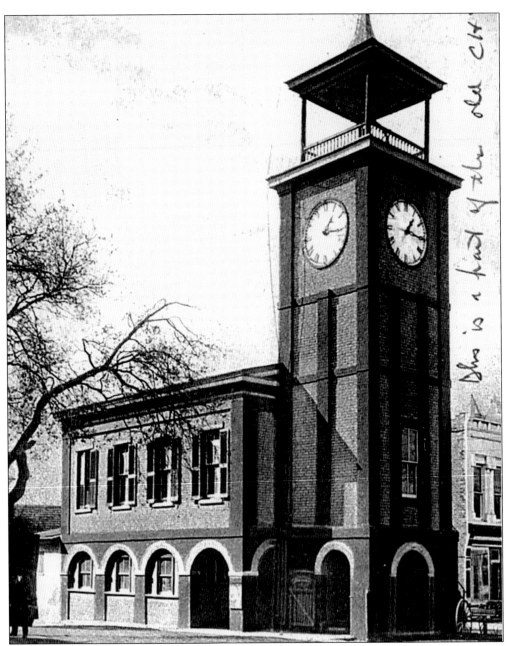

This is a head of the old city

Georgetown's most recognized building is located on the site of an earlier wooden market demolished in 1841 to stop a fire sweeping Front Street. This Greek Revival town hall and city market has served various functions since its construction in 1842. The clock tower was added about 1845. The *Georgetown Times*, established in 1797 and now South Carolina's oldest newspaper, had offices under the clock in what was previously an open market and later enclosed as a jail. The *Times*'s name appears on the building in both views, opposite page. The chamber of commerce was also once housed here. In celebration of South Carolina's Tricentennial in 1970, The Rice Museum organized and has occupied this National Register of Historic Places property continuously.

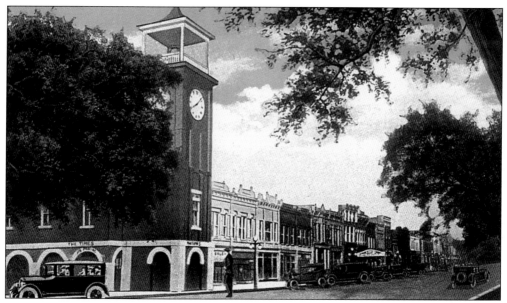

Georgetown's former town hall and market building, shown in 1926 at the terminus of Screven Street, is now surrounded by Lafayette Park. The park and a plaque on the front of the building honor the Marquis de Lafayette, a 19-year-old Frenchman who arrived on nearby North Island in 1777 to assist the American Revolutionary cause. A bust of Lafayette by local artist Caroline Bull Grannis highlights this distinctive garden, maintained by the Low Country Herb Society. (See page 27 for more about Lafayette.)

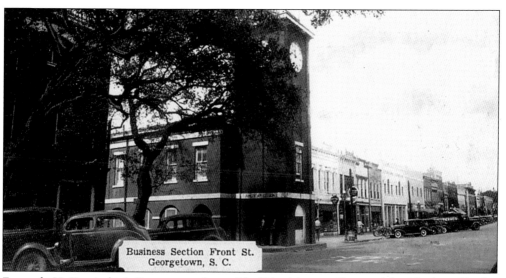

Formerly H. Kaminski & Company and now The Rice Museum Shop and the Charlotte Kaminski Prevost Gallery, the 1842 hardware building, far left, is where T.W. Daggett built a mine that sank the U.S.S. *Harvest Moon*, Union flagship of Adm. Thomas Dahlgren, on March 1, 1865 in Winyah Bay. The location of the sinking is shown on page 75. A live oak tree in front of this building recalls its past; an advertising sign for Tarr & Wonson's Racing Compound is permanently affixed to the tree's bark, which has overgrown its vintage message. This view is postmarked 1938.

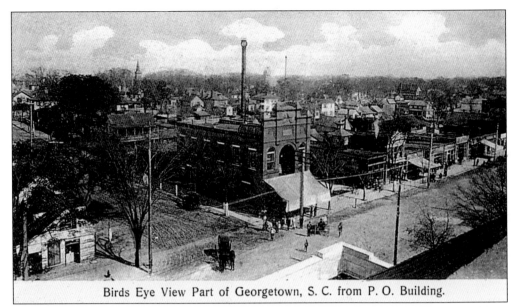

Birds Eye View Part of Georgetown, S. C. from P. O. Building.

A "Bird's Eye View of Georgetown," taken from the roof of the city's new Federal Building, overlooks the intersection of Front and King Streets. The dominant visible structure is D.J. Crowley's Grocery store, which was sold in 1913 when Crowley died and was razed in the 1960s. A photographer on the roof did not go unnoticed, as local citizens are seen standing in the street, gazing upward. Note the spire of the newly constructed Duncan Methodist Episcopal Church (now Duncan Memorial United Methodist Church) towering on the horizon of this postcard, mailed in 1909. (Courtesy of Robert Hinely.)

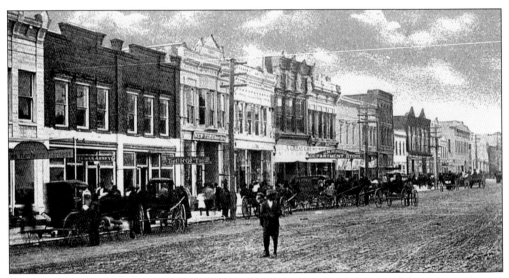

Pedestrians, buggies, and horses line an unpaved Front Street in this turn-of-the-century image. Legible business signs read, from left to right, (Congdon's) "Groceries, Hardware, Harness," "Chas. Assey," "The Croft Drug Co.," "New York Notion Store," "C.L. Ford," and "J.M. Ringel Dept. Store." C.L. Ford's grocery and hardware business operated from 1894 to 1966, serving local and maritime traffic. The store's name appears on the wagon parked in front of its entrance, and C.L. Ford's residence is shown on page 48.

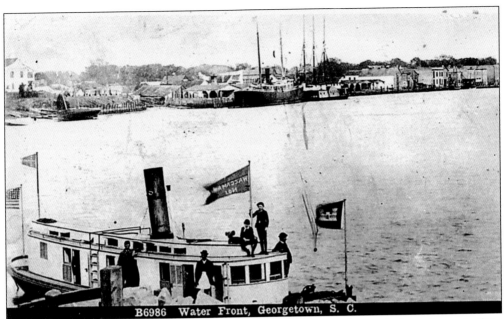

The steamer *Waccamaw No. 1* displays a U.S. Corps of Engineers flag on its bow. It was built in 1897 by S.R. Easterby at the shipyard in Smithfield, a village on the Estherville-Minim Creek Canal, now the Intracoastal Waterway, south of Georgetown. In 1900, a larger *Waccamaw* steamship became one of the first ships of Atlantic Coast Steamship Company to transport timber to New York for Atlantic Coast Lumber Company. (Courtesy of Robert Hinely.)

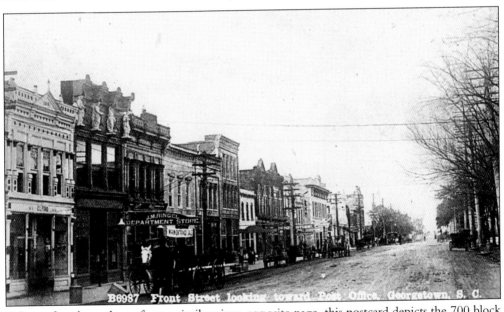

Taken a few doors down from a similar view, opposite page, this postcard depicts the 700 block of Front Street about 1906. It offers perhaps the best image of the Brilles & Sons store, second building from the left, with its decorative facade featuring the four seasons of the year personified as women. These statuesque ornaments were removed during a renovation, and their present status is unknown. The store's proprietor was Sol Brilles.

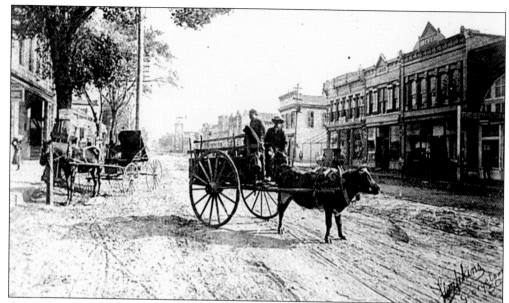

This postcard, entitled "Georgetown (S.C.) automobile," has a theme for which multiple images have been located. In this signed photo by D.C. Simpkins, two men are seated in an ox cart beside Iseman Drug Company, 807 Front Street. Simpkins established the first photography studio in Georgetown in 1901. Similar views appear on page 21 and on the front cover of this book, described on page 4.

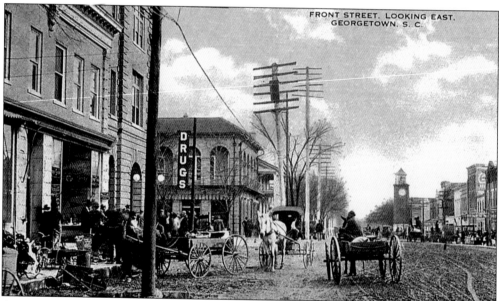

A crowd surrounds Bank of Georgetown's entrance and wraps around the building in this early 20th-century view on the corner of Front and Broad Streets. Wagons are stopped in the street while their drivers observe the gathering. Was this opening hour traffic around 1910, or perhaps payday at Atlantic Coast Lumber Corporation? One can only speculate on what precipitated this postcard photograph. Beside the bank, left, is the Georgetown Drug Store, which opened in 1909.

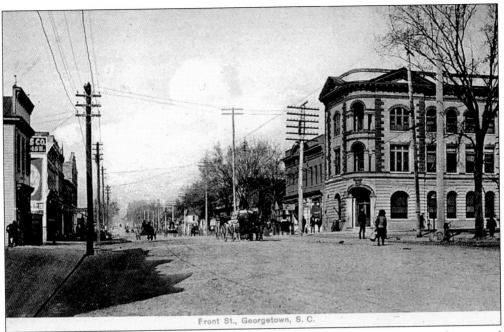

Front St., Georgetown, S. C.

Bank of Georgetown, right, dominates this early 20th-century view at the corner of Front and Broad Streets. Nicknamed "Morgan's Bank" for Pres. William Doyle Morgan, this bank occupied its new building in April 1904. The following year would bring additional progress to Front Street, as "horseless buggies," or automobiles, began to appear in Georgetown.

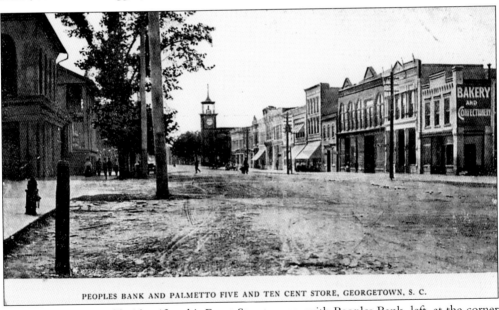

PEOPLES BANK AND PALMETTO FIVE AND TEN CENT STORE, GEORGETOWN, S. C.

The clock tower readily identifies this Front Street scene, with Peoples Bank, left, at the corner of Broad Street. The bank's location is historic. It was the site of a tavern where Winyah Indigo Society first met and local British headquarters during the American Revolution. The building is now The Rice Paddy, a restaurant wherein the vault stores wine. This c. 1905 view was sold at Palmetto Five and Ten Cent Store, located beside the bank. (Courtesy of Bill Benton.)

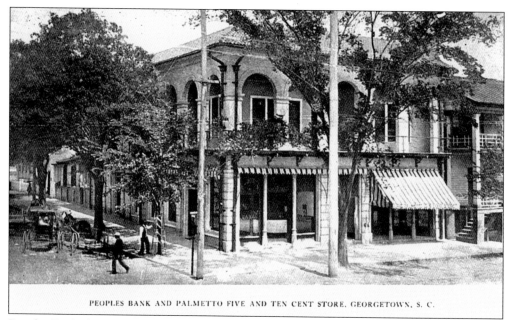

PEOPLES BANK AND PALMETTO FIVE AND TEN CENT STORE, GEORGETOWN, S. C.

Peoples Bank, located at the corner of Front and Broad Streets, and Palmetto Five and Ten Cent Store, with the striped awning next door, were prominently located almost a century ago. H.W. Fraser was president of Peoples Bank when it opened in 1904, the same year that Bank of Georgetown occupied its new building on the opposite corner. Partially visible on the right is the Gladstone Hotel.

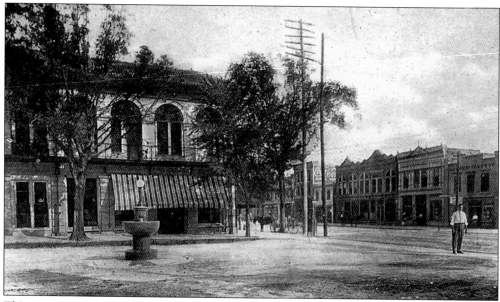

This granite water fountain, topped with a globe light and situated in the center of Broad Street between two banks, was a 1911 addition to downtown Georgetown. It was donated by the National Humane Alliance to provide water for horses and pets. Today, this fountain is the centerpiece of a small park at the corner of Front and Screven Streets, near The Rice Museum. (Courtesy of Bill Benton.)

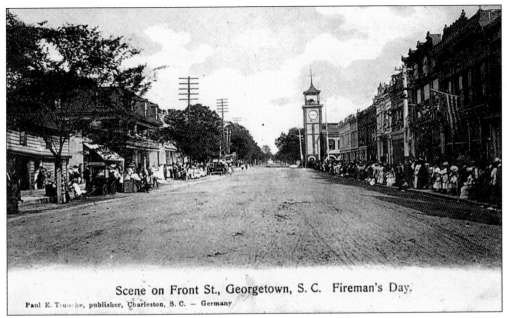

Scene on Front St., Georgetown, S. C. Fireman's Day.

Paul E. Trouche, publisher, Charleston, S. C. — Germany

Georgetown residents line Front Street for the annual Fireman's Day parade and inspection, in this 1909 scene. Back then, local fire engine companies were segregated. The Star Fire Engine Company and Heston Fire Engine Company were comprised of African Americans. The Winyah Steam and Fire Engine Company and Salamander Hook and Ladder Company were comprised of caucasians. These companies engaged in friendly but spirited games of competition at this annual event.

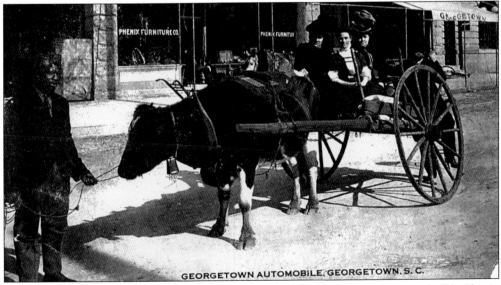

GEORGETOWN AUTOMOBILE, GEORGETOWN, S. C.

It was a "Kodak moment" when three well-dressed women posed in an ox cart beside Phenix Furniture Company on Front Street. A man standing behind the cart offers a reassuring arm to the woman on the right, while the women's elaborate hats are in sharp contrast to the primitive cart. In the background, right, are Georgetown Drug Company and Bank of Georgetown. This postcard was mailed in 1912.

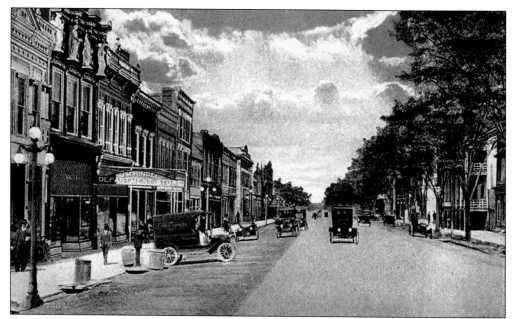

Historical reproductions of the triple globe street lights installed in 1914 can be found on Front Street today. This postcard, published in 1917, shows the 700 block of Front Street. Georgetown's original town plan designated commercial lots opposite the street from the river, with the waterfront limited to piers and warehouses. Gradual encroachments resulted in commercial enterprises shifting to the waterfront. Today, both sides of Front Street's commercial district are well developed.

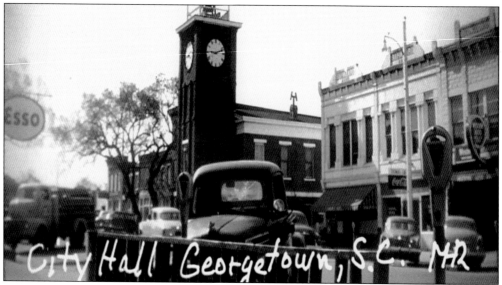

Thomas' Cafe and the Western Auto Store are visible across Front Street in this 1950 postcard. Note the parking meters, now removed, in the foreground and the Esso gas sign, far left. The same sign appears in the postcard, opposite page. The Esso station is gone, replaced with a mini-park featuring Georgetown's historic water fountain, shown on page 20, and public restrooms for visitors to downtown and Harborwalk, the city's riverfront boardwalk.

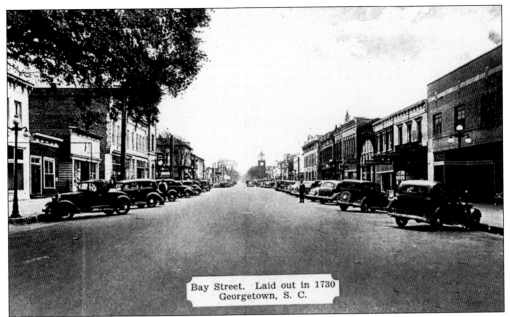

Bay Street. Laid out in 1730
Georgetown, S. C.

Front Street, pictured in the early 1930s, was once called Bay Street. Its 100-foot width must have seemed enormous in 1730. Now, the wide streets accommodate diagonal parking spaces, providing easy access to businesses. Broad and Highmarket Streets are also 100 feet wide; other original streets are 75 feet wide. Proprietors of early businesses often enjoyed the convenience of living above their Front Street shops.

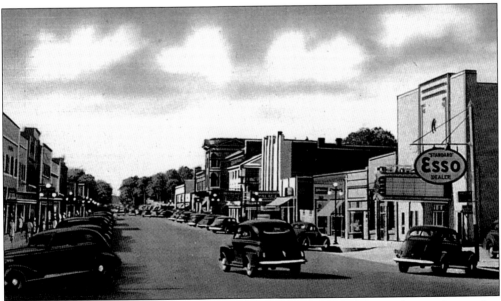

George A. Colbert owned the Esso gas station at the corner of Screven and Front Streets, just beyond this 1941 view, far right. The Esso brand is now Exxon, and Colbert's station is a city park. Screven Street was named for Elisha Screven, who laid the original George Town plan, and whose father, Rev. William Screven, was thought to be the first Baptist minister in provincial South Carolina.

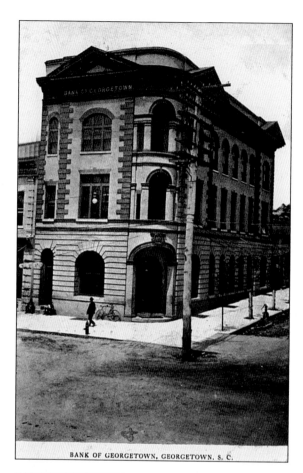

BANK OF GEORGETOWN, GEORGETOWN, S. C.

Bank of Georgetown opened in April 1891 with $50,000 in stock subscriptions, which were soon increased to $100,000. Thirteen years after opening, the bank moved to this auspicious building at the intersection of Front and Broad Streets. Postmarked 1908, this view showcases Bank of Georgetown's new building, symbolically situated between a new fire hydrant, left, and an old water pump, right.

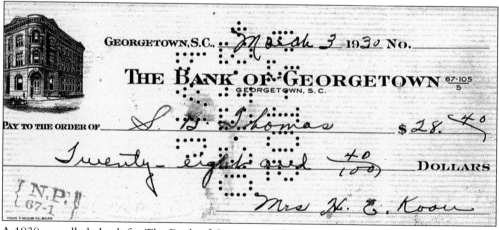

A 1930 cancelled check for The Bank of Georgetown bears a detailed etching of its building. Its predecessor, Bank of Georgetown, failed in January 1927, due to an embezzlement scandal. The following month, The Bank of Georgetown, newly chartered, opened in the old bank's offices. The Bank of Georgetown reorganized in 1929, under Peoples State Bank, which failed in January 1932. This check is interesting because it is dated after the 1929 reorganization that absorbed The Bank of Georgetown into the Peoples State Bank system.

24

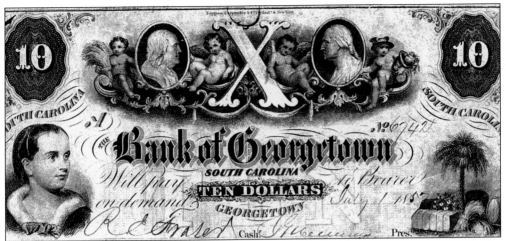

The antebellum Bank of Georgetown was chartered December 21, 1836 with $200,000 capital, and it failed during the Civil War. This $10 bank note, dated July 1, 1857, is signed by R.E. Fraser, cashier, and J.G. Henning, president. Henning was the bank's fourth and final president. The engraved note features cameo images of Benjamin Franklin and George Washington set amidst four cupids and a Roman numeral ten. In the right corner, beneath a palmetto tree, are symbols of Georgetown's economy—rice sheaves, a cotton bale, and branch, plus barrels used for shipping rice and naval stores.

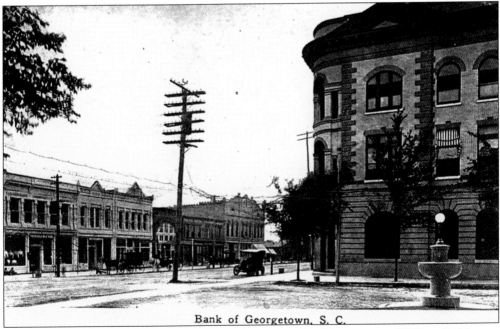

Bank of Georgetown, S. C.

This postcard, cancelled 1916, shows another view of Bank of Georgetown. William D. Morgan was president; Jonathan I. Hazard was vice president and cashier. Other banks that opened in the following years included Peoples Bank of Georgetown, 1904; Farmers and Merchants Bank, 1913; and Planters and Mechanics Bank, 1919. All three of these banks failed by the end of 1929. Bank of Georgetown survived only by being absorbed into the larger Peoples State Bank system.

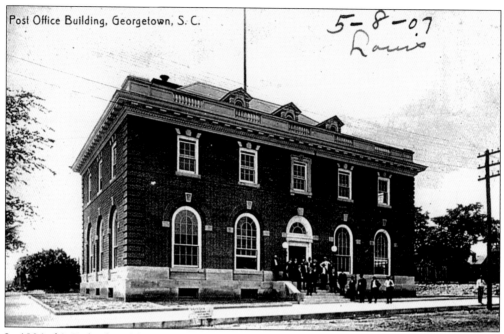

Post Office Building, Georgetown, S. C.

5-8-07
Lewis

In 1906, this Federal Building was erected at 1001 Front Street. The U.S. Post Office was on the main floor, and the U.S. Customs House and Selective Service Board were upstairs. The post office moved to the corner of Highmarket and Wood Streets in 1967 and to the corner of North Fraser and Charlotte Streets in 2000. Now privately owned, this Front Street landmark houses the Georgetown County Chamber of Commerce and professional offices. The postcard was mailed in 1907.

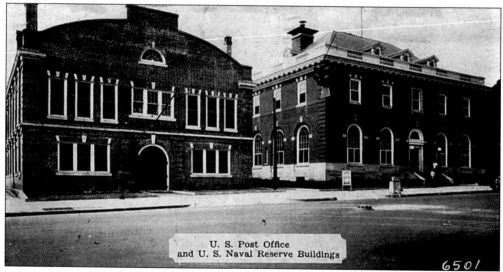

U. S. Post Office
and U. S. Naval Reserve Buildings

6501

The U.S. Naval Reserve building, left of the post office at the terminus of King Street, was built in 1936 with Public Works Administration funds and labor provided by reserve members, who also donated one day's pay per quarter to the project. In 1976, Georgetown's reserve unit merged with Charleston units, and this building was sold. It burned in 1984 and is now the site of Rainey Park, explained on page 12. Iseman Drug Store published this postcard, mailed in 1940.

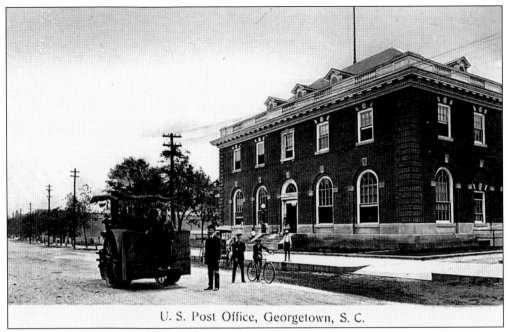

U. S. Post Office, Georgetown, S. C.

The brightness of Georgetown's unpaved streets in early 20th-century views is due to their oyster shell foundation. Oyster shells were crushed by a Case steam roller, seen in front of the post office. Now, utility repairs involving historic district streets often expose portions of the oyster shell layer beneath the pavement. The city has had sidewalks since 1900.

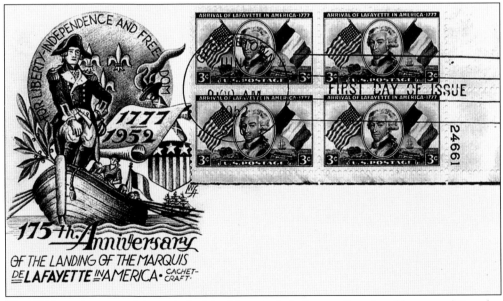

The 175th anniversary of the arrival of the Marquis de Lafayette, French nobleman and Revolutionary War hero, was celebrated at Georgetown in 1952. This First Day Cover envelope, postmarked Georgetown, June 13, 1952, displays a plate block of the Lafayette commemorative stamp issue. Since Lafayette landed on nearby North Island, his name has been widely used locally. In 2002, the U.S. Congress named Lafayette the sixth honorary American citizen.

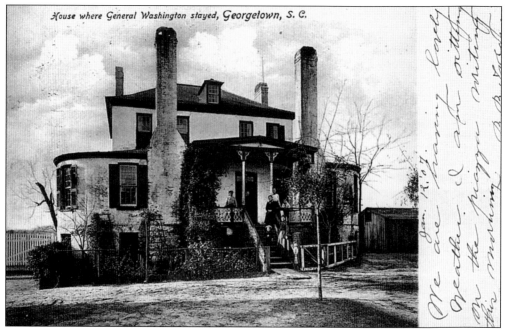
House where General Washington stayed, Georgetown, S. C.

The Robert Stewart house, photographed on New Year's Day in 1902 and shown above and below, is a two-and-a-half-story, Georgian brick home, built *c.* 1750. In the ensuing 250 years, it has experienced multiple architectural revisions. George Washington is believed to have stayed here during his 1791 Southern tour, when the house belonged to Daniel Tucker, who had purchased it from Stewart and upgraded it. Tucker was active in local politics and owned Litchfield and Retreat Plantations. The only known historic brick home in Georgetown, this house has 15-inch thick exterior walls and is framed with 10-inch by 3-inch hand-hewn timbers. Located on the Sampit River bluff at 1019 Front Street, it is leased by the city of Georgetown. It was recently restored following fire damage and houses offices of the adjacent Kaminski House Museum. The postcard above was mailed in 1907, and the one below was mailed in 1912, at which time the Robert Stewart house was local headquarters for the Elks' fraternal organization.

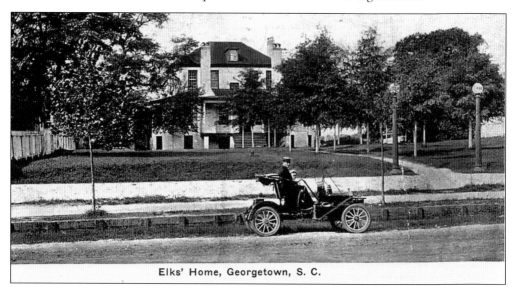
Elks' Home, Georgetown, S. C.

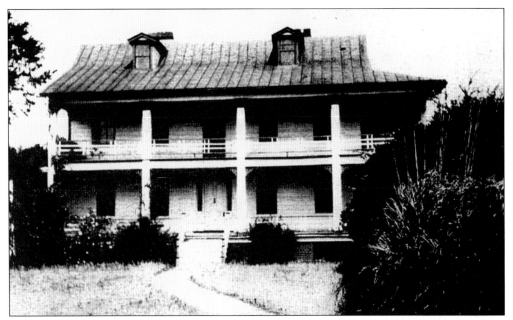

The house at 1003 Front Street was built *c.* 1769 by the Paul Trapier II family. Trapier was an entrepreneur whose nickname "King of Georgetown" was an appropriate title for one living on the highest riverfront elevation in town. Congdon and Daggett are names of former residents of the house. Now the Kaminski House Museum, this house and its contents were bequeathed to Georgetown in 1972 by owner Julia Kaminski, in memory of her husband, Harold, and her mother-in-law, Rose Kaminski, whose house is shown on page 58.

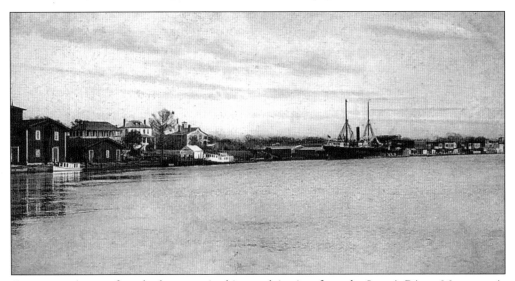

Georgetown's waterfront looks serene in this nostalgic view from the Sampit River. Most prominent are the Robert Stewart and Kaminski houses, center left, a tall tree rising between them. The massive chimney of Georgetown's new Federal Building, built *c.* 1906, is visible over the roof of the Kaminski house. Port activity on Front Street peaked in the early 20th century. Now, the Port of Georgetown shares port facilities with International Paper Company, operating upriver, where a channel provides direct access to Winyah Bay.

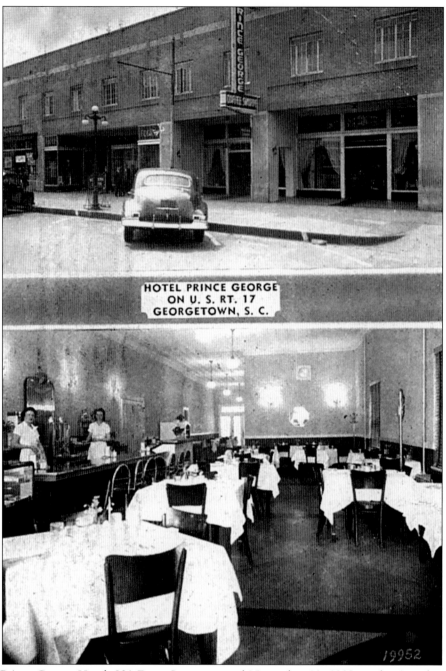

HOTEL PRINCE GEORGE
ON U. S. RT. 17
GEORGETOWN, S. C.

The Prince George Hotel, 821 Front Street, opened November 11, 1932 on the site where the Standard Opera House had burned. The hotel was named for Prince George Winyah Parish. Harry Fogel was its first proprietor; later, Abe Fogel assumed his father's position. Originally 22 rooms, the hotel expanded to 50 rooms with a third-story addition in 1952. This divided postcard, mailed in 1942, features the hotel's entrance and coffee shop.

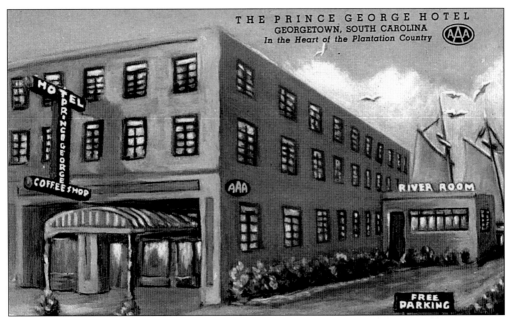

A 1950 postcard of the Prince George Hotel shows its new River Room restaurant on the waterfront of the Sampit River. Fogel's Department Store occupied the former coffee shop location after the hotel's new restaurant opened. In 1952, the glass-enclosed restaurant modernized with air conditioning. The River Room name survives today on a nearby restaurant.

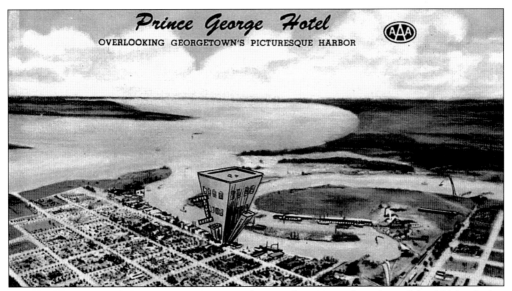

This 1951 postcard of the Prince George Hotel is an advertising adaptation of the 1901 painting seen on page 8. Its caricature representation of the hotel visually conveys the message that the Prince George was in the heart of Georgetown. When Bernard Baruch was in residence at nearby Hobcaw House, his entourage stayed at the Prince George. This entourage included U.S. Secret Service agents when President Franklin D. Roosevelt visited Baruch in 1944. Baruch avoided telephones by disallowing them at Hobcaw, opting instead to use this hotel's lobby telephone for necessary calls.

31

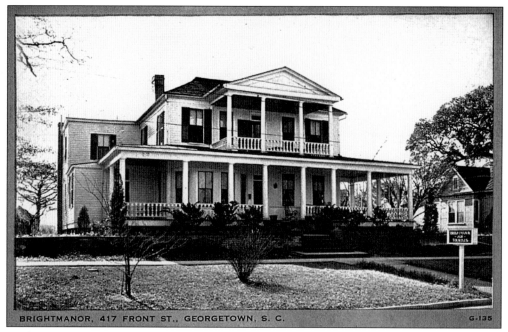

BRIGHTMANOR, 417 FRONT ST., GEORGETOWN, S. C. G-135

Brightmanor, 417 Front Street, was the home of Thomas W. and Ida S. Brightman, who rented rooms to tourists in the 1940s. It was one of 21 boarding houses in Georgetown advertising furnished rooms for guests in 1941. The house is now a private residence.

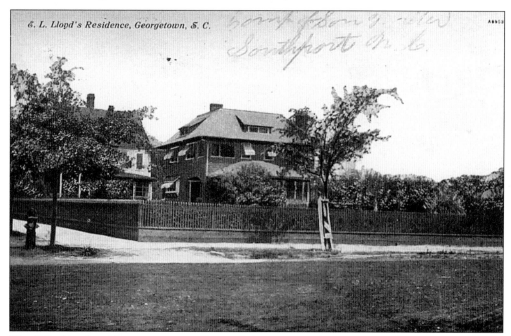

The E.L. Lloyd residence was one of several Georgetown houses pictured in a postcard series published in 1911. Lloyd was widowed in 1901 when his wife, the former Bernice Segler, died at age 24. An infant son also died. This corner house was located in Georgetown's historic district. Other houses in the series are shown on page 48. (Courtesy of Robert Hinely.)

Razed in 1953, Farris residence was the home and dental office of Dr. H.A. Farris. It was located on the northeast corner of Front and St. James Streets. The design of this house was symmetrical; octagonal rooms were located on two stories at four corners of the house, interspersed with eight porches and embellished with ornamental trim. Alas, this Victorian house was an architect's folly, comprised largely of windows and doors. (Courtesy of Curt Teich Postcard Archives.)

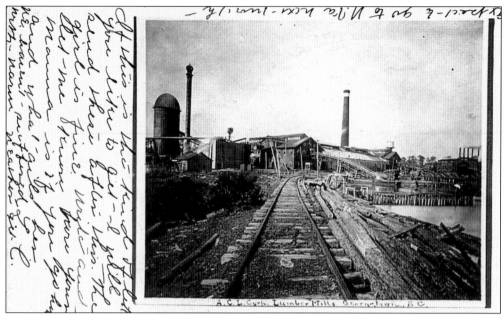

This 1905 postcard shows railroad tracks leading into the 56-acre site that Atlantic Coast Lumber Corporation occupied west of the Sampit River bend, beginning in 1899 and ending in 1932. A 1913 fire destroyed two of four sawmills, but proved beneficial when a steel and concrete lumber plant replaced the burned mills, making A.C.L. the largest lumber operation on the East Coast.

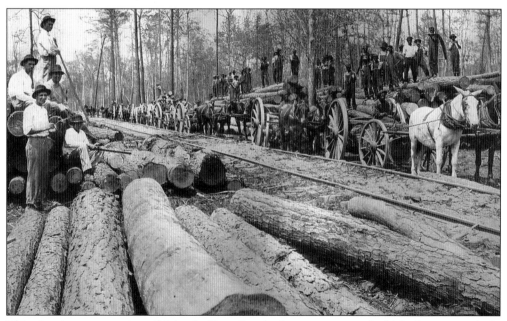

This view is representative of Atlantic Coast Lumber's team camps, of which there were six in 1916. On the left are several foremen, and on the right are many sawyers. The second man from the right is shouldering a saw, manually operated by two men. Lightweight, portable houses enabled employees to establish temporary camps convenient to their cutting site. From mules and carts, logs were transferred to Georgetown by river or rail.

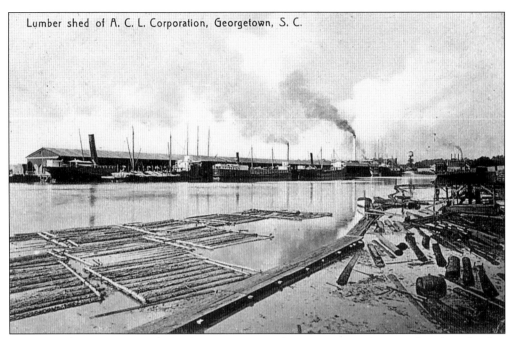

Lumber shed of A. C. L. Corporation, Georgetown, S. C.

This page shows two views of Atlantic Coast Lumber Corporation's 1,200-foot-long lumber shed, located across the river from Georgetown, on the south bank of the Sampit River bend. Lumber brought by electric rail to this distribution shed could be loaded simultaneously onto five ocean vessels owned by Atlantic Coast Steamship Company, A.C.L.'s transportation subsidiary. "Atlantic Coast Soft Pine" was the trademark name by which the corporation established its reputation as the premier producer of short leaf yellow pine. By 1916, A.C.L. had a 50-year supply of standing timber, or stumpage. The above postcard was mailed in 1907, and the view below was published in 1914. (Courtesy of Curt Teich Postcard Archives.)

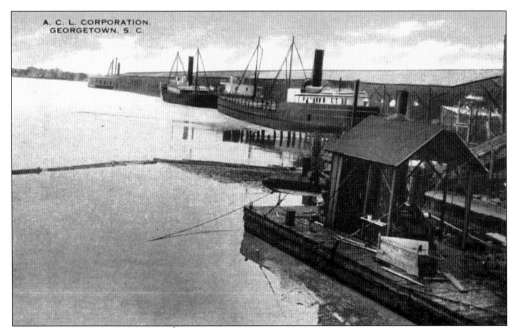

A. C. L. CORPORATION.
GEORGETOWN, S. C.

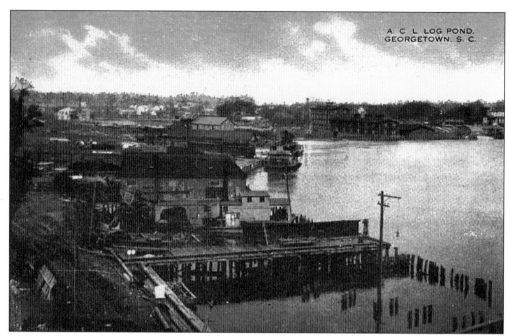

Atlantic Coast Lumber Corporation's log pond is outlined in the foreground of this view. Beyond it lies the city on the Sampit, where the tallest brick building, right center, is Georgetown Rice Milling Company, built in 1879. L.S. Ehrich was its mill superintendent. The rice milling company was located at the terminus of Wood Street and represented an effort to increase rice profits by milling locally. Waverly Mills, on the Waccamaw Neck, was the largest nearby commercial rice mill.

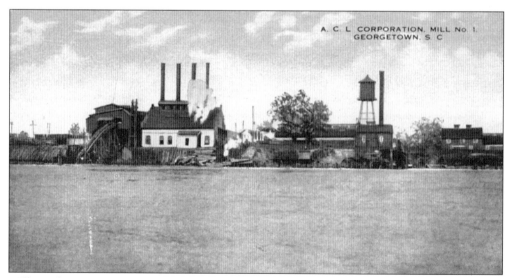

Mill number one, seen in 1914, was one of more than 24 main buildings on the site of Atlantic Coast Lumber Corporation, the largest of four area lumber mills having a combined employment of 5,000 workers at peak production. The unique feature of A.C.L. was recycling; all waste products were either burned as boiler fuel or sold to the adjacent DuPont Powder Company, for use in making ethyl alcohol. (Courtesy of Curt Teich Postcard Archives.)

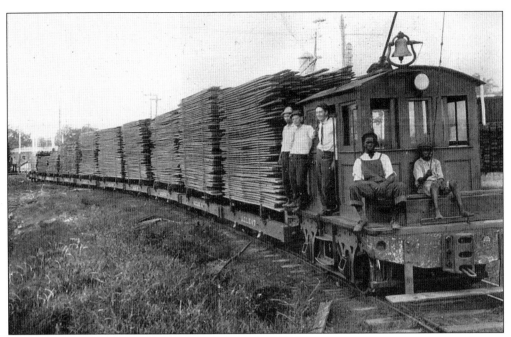

Kiln-dried lumber is transferred from the storage shed to the shipping dock by a nine-mile network of electric trains moving throughout the lumber yards of Atlantic Coast Lumber Corporation. At its peak, A.C.L. produced 700,000 board feet of lumber daily, consisting of 75 percent short leaf yellow pine, 10 percent cypress, and 15 percent other hardwoods. Its powerful turbine generators also supplied electricity to the city of Georgetown in the early 20th century.

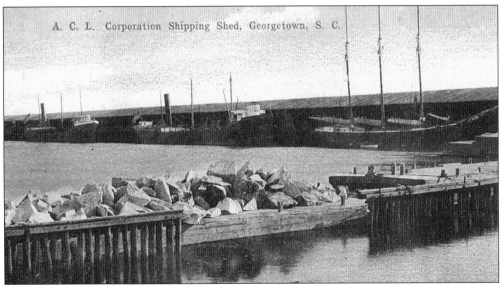

Boulders used to build the north and south jetties at the entrance to Winyah Bay arrived at the coastal port by train and awaited transportation on barges from A.C.L.'s dock to their North and South Island destinations. Jetty construction began in 1890 and ended in 1904. Mayor William D. Morgan led local efforts to secure funding for these and other harbor improvements, which cost the U.S. government over $2.5 million a century ago.

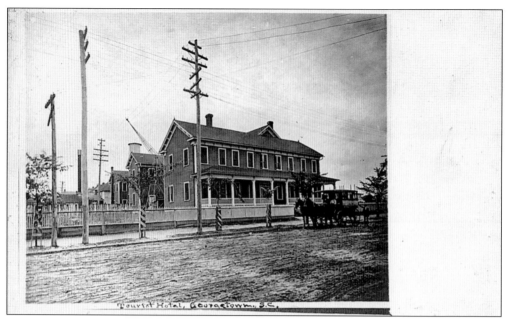

In 1900, Atlantic Coast Lumber Corporation built the sprawling Atlantic Hotel, renamed the Tourist Hotel, on the corner of Fraser Street and Winyah Road, across from the depot of the Georgetown and Western Railroad, later the Seaboard Air Line Railway Company. In this view shortly after 1900, a carriage taxi awaits guests at the hotel entrance. The Seaboard Railway folded during the Depression, along with A.C.L. and local banks.

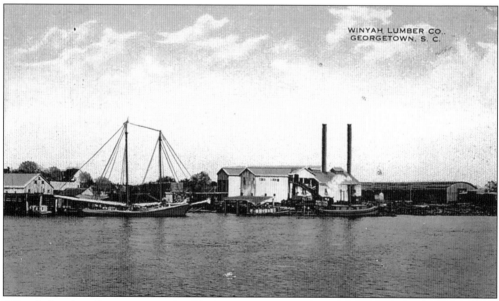

Winyah Lumber Company organized in 1898 on 40 acres that included a mile of Sampit River frontage, previously the site of the Palmetto Mill, southeast of St. James and Front Streets. With new machinery, the company produced 40,000 board feet of lumber daily, supplied with the support of a company tugboat, the *Pender*. Principals in this operation were P.J. Doyle, H.J. Theiker, G.A. Doyle, and J.A. Thrall. (Courtesy of Robert Hinely.)

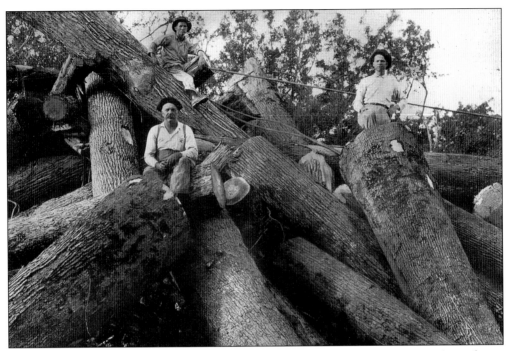

Lumbermen employed by Atlantic Coast Lumber Corporation in 1915 rest on massive red gum and white oak logs destined for Georgetown. In order to assure a continuous supply of timber for milling, A.C.L. optioned large tracts of heavily timbered land in eight South Carolina counties, including Georgetown. They formed logging teams provided with portable housing and laid hundreds of miles of narrow-gauge railroad rails deep into these woods to facilitate harvesting the timber.

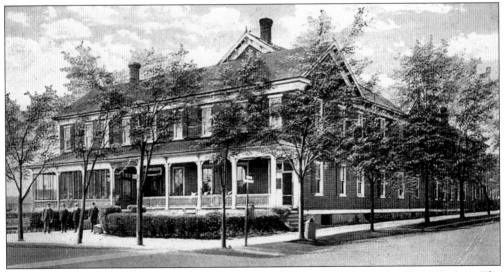

Small trees planted near this hotel when it opened are beginning to mature in this 1920 view. The hotel, also seen on the opposite page, was called the Tourist Hotel by 1920. Like most Atlantic Coast Lumber Corporation buildings, it remains only in photographs and memories. (Courtesy of Bill Benton.)

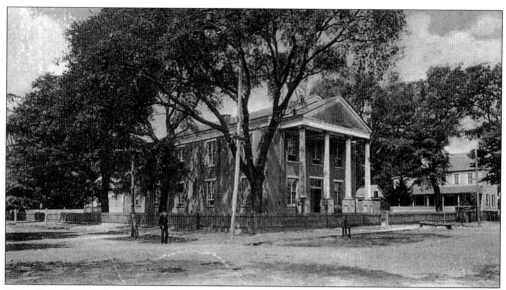

Winyah Indigo Society built this meeting hall and school at 509 Prince Street in 1857; previously the society had met in a tavern on the corner of Front and Broad Streets, referenced on page 19. A social group of planters, the society began in 1740 and received a Royal Charter from King Charles of England in 1755. Membership dues were originally paid in indigo, thus the name. Excess treasury funds inspired a philanthropic mission to educate the poor; the resulting Winyah School was the nucleus of Georgetown's public school system. Thomas Lynch Sr. was the founding president of Winyah Indigo Society, which hosted George Washington during his visit. It remains an active society today.

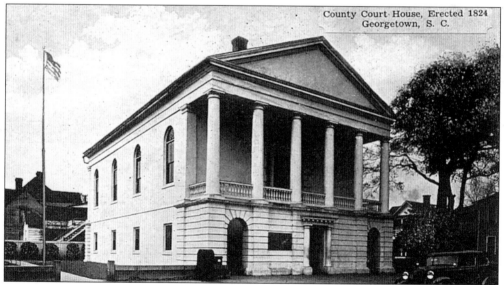

This is Georgetown County Court House, on the corner of Prince and Screven Streets, in 1935. The plaque to the left of the sidewalk entrance honors Georgetown County citizens who served in World War I, and was dedicated on Armistice Day, 1926, by the Daughters of the American Revolution. Expanded in 1963, this court house has served Georgetown County citizens for over 175 years.

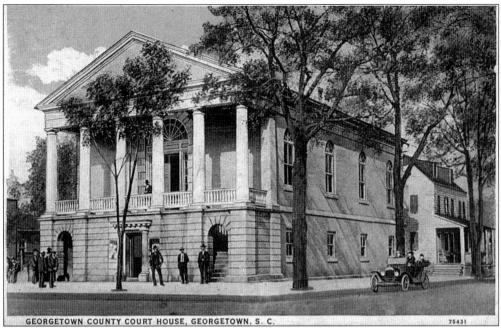

GEORGETOWN COUNTY COURT HOUSE, GEORGETOWN, S. C. 75431

Georgetown County Courthouse was built in 1824 by Russell Warren, using a design by Robert Mills, state engineer and architect at that time. Mills believed that people should look up to the law and that record storerooms should be fireproof. Those principles are reflected in this building; the courtroom is upstairs, and ground floor walls are the thickness of a vault. When Warren finished this building, he built a similar courthouse in Horry County. This is a 1917 view of the court house.

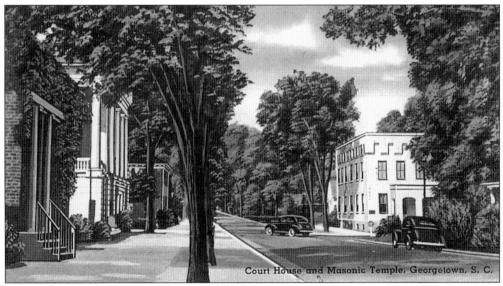

Court House and Masonic Temple, Georgetown, S. C.

Screven Street is seen in 1941, approaching the Prince Street intersection. On the left is the brick sheriff's office, later relocated across the street. Beyond is the Georgetown County Courthouse. On the right is the former Masonic Temple, now privately owned. The shade trees lining this and other streets were Mayor William D. Morgan's arbor project 40 years earlier.

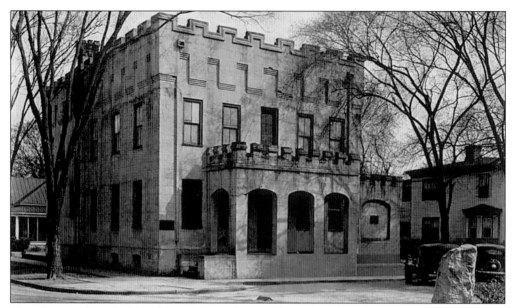

The former Masonic Temple on Prince Street, shown in 1937, has a disputed past. Some historians claim it was America's only Colonial banking house, while other historians remain doubtful. It is known that the building predates the American Revolution. Documented 20th-century history records its usage as the Winyah Inn from 1902 to 1908, the Georgetown Rifle Guards Armory from 1908 to 1914, and the Masonic Temple thereafter. It is now vacant and privately owned.

The sun is shining and rooftop snow has melted, but Prince Street remains under a white blanket in this card, postmarked Bucksport, 1909. On the right is the Samuel and Joseph Sampson house, 614 Prince Street. This Georgian house, also called the Ward house, dates to the mid-18th century. Its original kitchen building is restored and provides a rare glimpse of a functional kitchen 250 years ago. The building in the background was the Winyah Inn, and later the Masonic Temple.

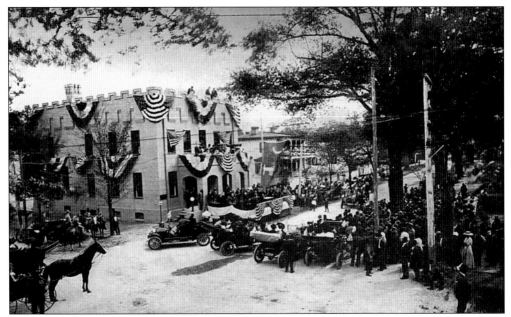

The Georgetown Rifle Guards dedicated their armory on November 17, 1909, the year after they purchased the former Winyah Inn, below, and altered its facade to resemble an armory. Six years later, they sold it to the Winyah Masonic Temple Association. Organized in 1859, the Georgetown Rifle Guards served as Company A, 10th Regiment, S.C. Militia, under Brig. Gen. Arthur M. Manigault and Capt. Plowden C.J. Weston. Sol Emanuel, a member of Company A, delivered the address at this historic dedication of 632 Prince Street.

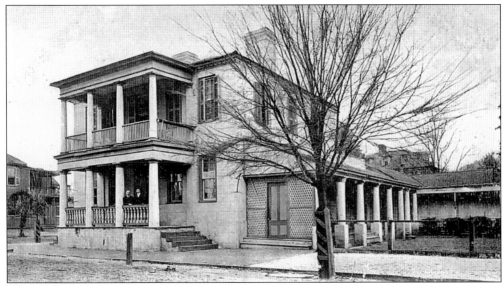

The Winyah Inn, 632 Prince Street, was operated by Mrs. Jessie Theo Butler from 1902 to 1908, prior to the building's conversion to an armory. In the late 19th century, this was the Georgetown Hotel. Several nearby houses accommodated overflow guests of the Winyah Inn. The postcard is a hand-colored adaptation of a D.C. Simpkins photo, taken during the inn's brief six years of operation. (Courtesy of Annette Coles.)

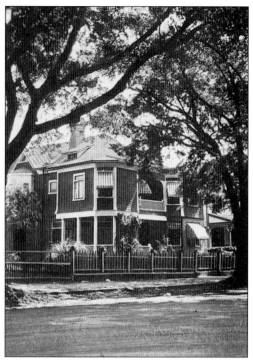

This card, postmarked 1911, shows the ill-fated home of Georgetown mayor Walter Henry Andrews, at 518-520 Prince Street. This was the city's first home to have furnace heat, and it caught fire and burned, along with three adjacent homes, on December 17, 1914. Andrews was superintendent of the Georgetown and Western Railroad. He helped establish the nearby town, below, that carries his name and was mayor of Andrews from 1920 to 1928.

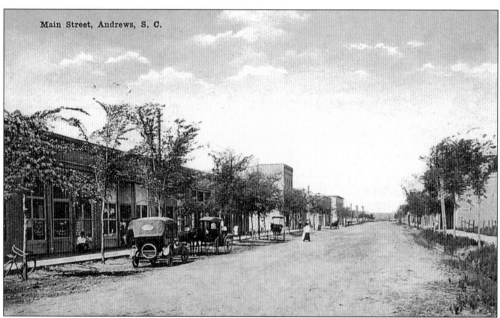

Main Street, Andrews, S. C.

This 1925 Main Street scene was the only vintage postcard found for Georgetown's neighboring town of Andrews and is included with W.H. Andrew's earlier residence, above. The town of Andrews began as a railroad stop on the Georgetown and Lane Railroad, renamed the Georgetown and Western Railroad. Adjoining logging communities of Harpers and Rosemary consolidated in 1909 to form Andrews. The Old Town Hall Museum, built *c.* 1915 and located on Andrews's Main Street, archives its history for future generations.

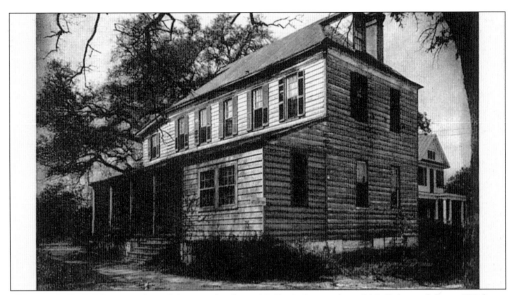

The Frances Withers Colonial house, built *c.* 1760, is located at 513 Prince Street. Withers, whose father received one of Georgetown's earliest land grants in 1736, owned several Georgetown houses and multiple Sampit River plantations, including Friendfield Plantation. James Carr Congdon bought this house at auction in 1881. The enclosed porch addition, now removed, was The Little Gift Shop, operated by Congdon's daughter, Laura Aileen Congdon, who lived here 60 years ago. The house in the background is a bed and breakfast named the Live Oak Inn, for the tree described below.

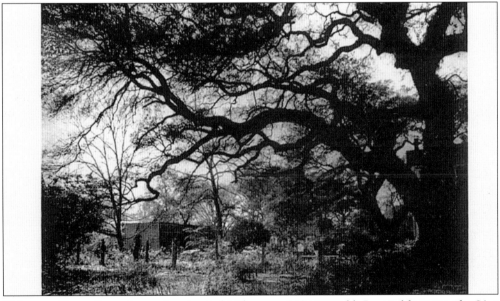

This magnificent live oak tree is estimated to be over 550 years old. Located between the Live Oak Inn and the Francis Withers Colonial house on Prince Street, it is a State Champion–South Carolina tree registered with The American Forestry Associates. Live oaks are unique in that their crown spread often exceeds their height. When last measured, this tree was 120 feet tall and had a crown spread of 125 feet.

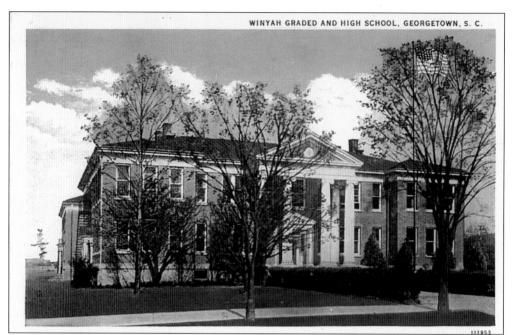

WINYAH GRADED AND HIGH SCHOOL, GEORGETOWN, S. C.

Winyah Graded and High School is pictured in 1926. Georgetown County had only three high schools in 1930; the others were at Andrews and Rhems. Additionally, the county had four schools with one teacher, two schools with two teachers, and three schools with more than three teachers, for a total of 12 schools. Today, Georgetown County School District has 19 schools and is the county's largest single business employer.

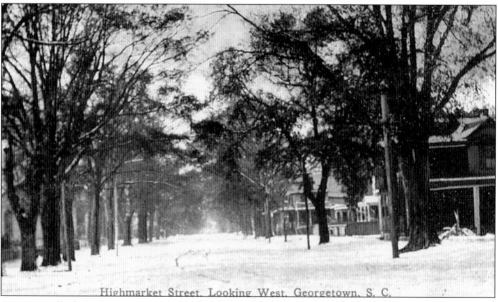

Highmarket Street, Looking West, Georgetown, S. C.

Snow usually brings an unexpected school holiday for Georgetown's children. The snow was considered rare enough to merit postcards for sharing the event with others. Pictured on Highmarket Street looking west, postmarked 1914, it is one of three local snow scenes in this book; others are on pages 42 and 60.

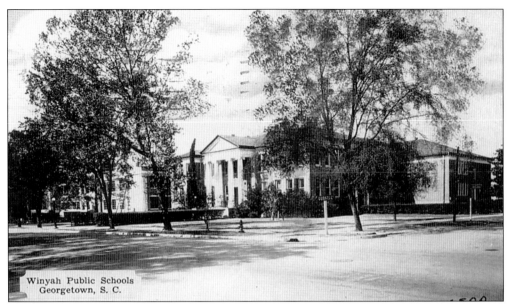

Winyah public schools evolved from the Winyah Indigo Society's school described on page 40. The columned building shown above was occupied in 1908 with classrooms for grades 1 through 10 and a large auditorium. In 1938, a new Winyah High School was built, left, behind the trees and bordering Dozier Street. It was destroyed by arson in 1981. A junior high school was also built in 1938 behind the original school building and fronting Cleland Street. This postcard, mailed in 1940, shows all three school buildings.

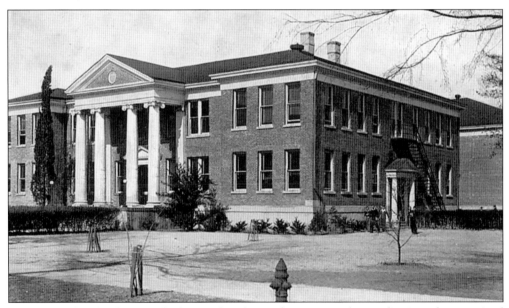

Winyah High School's 1908 facility, with a dozen classrooms and an auditorium, has remained empty since 1984. On November 6, 1981, the adjoining, newer high school burned in an unresolved case of arson. Pictured about 1939, the auditorium building is listed on the National Register of Historic Places, and plans for its restoration are under way. Winyah High and the Howard School for African Americans merged in 1984 to form Georgetown High School.

47

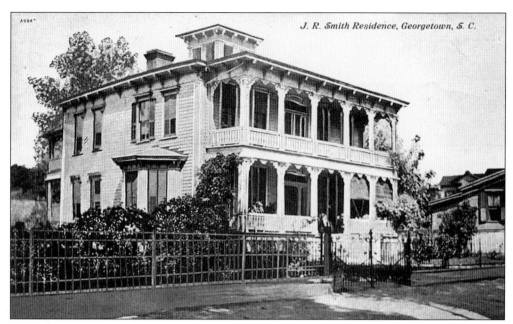

Labeled the "J.R. Smith Residence," this house at 722 Prince Street is now referenced by the name of its original owner, Marks Moses, a local merchant. It is topped with the city's only remaining widow's watch, so named because wives became widows watching from these observatories for husbands lost at sea. This 19th-century house, photographed in 1911, once served as a Jewish school. (Courtesy of Ed Carter.)

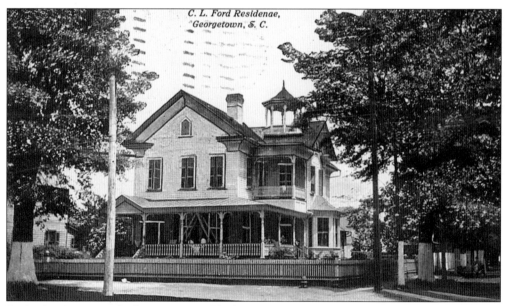

Beginning in 1894, Charles LaHue Ford had a grocery and hardware business at 711–713 Front Street. Ford's business, C.L. Ford and Sons, survived its founder to close in 1966. During the construction of Brookgreen Gardens, it handled all purchases and shipments for that endeavor. Ford's home, shown about 1910, is now divided into apartments at 1104 Front Street, on the corner of Wood Street. (Courtesy of Ed Carter.)

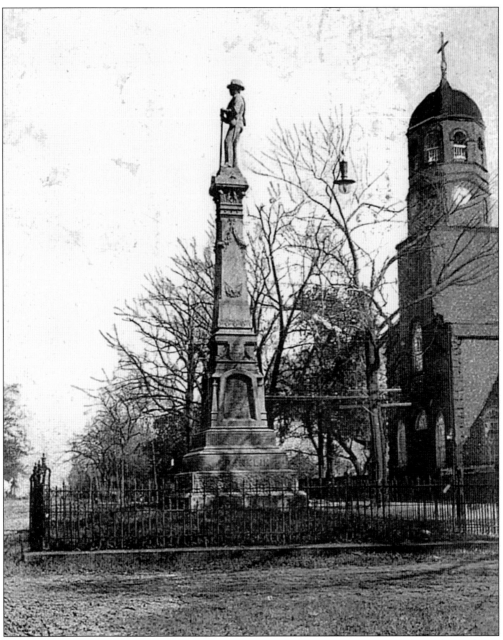

Postmarked 1908, this view of Georgetown's Confederate monument, dedicated April 13, 1891, shows its original location in the intersection of Highmarket and Broad Streets. Automobile traffic twice necessitated its relocation, and it is now in the Antipedo Baptist Church cemetery on Church Street, at the head of Screven Street. The monument memorializes Company A of the 10th S.C. Volunteer Infantry Regiment, known as Manigault's Brigade, and recognizes its service in battles from Corinth to Bentonville, including Murfreesboro, Missionary Ridge, Chickamauga, Atlanta, Franklin, and Nashville. Among the 1,175 members of the 10th S.C., 461 died in the war. Ceremonies held here on Confederate Memorial Day were discontinued in the 1930s.

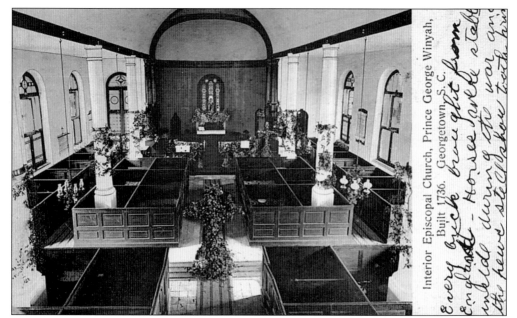

Interior Episcopal Church, Prince George Winyah, Georgetown, S.C. Built 1736. *Every brick free split from england – House saved retabl unhide during the war an the hewe steckhow toth hi*

A cross formed of ivy fills the center aisle, and smilax adorns the columns of Prince George, Winyah, Episcopal Church in this 1908 view, suggestive of an Easter service. This was originally an Anglican church; the Episcopal designation followed the American Revolution. Enemy troops occupied the sanctuary of this National Register of Historic Places church during the American Revolution and the Civil War. Confederate Brig. Gen. James H. Trapier is among the esteemed members of this church memorialized in this sanctuary.

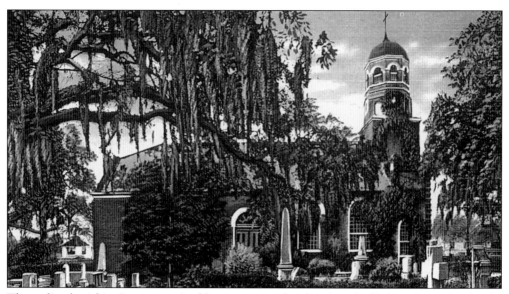

The earliest burial in Georgetown's oldest cemetery, the churchyard of Prince George, Winyah, Episcopal Church, was in 1767. Surnames found most frequently in the original portion of the cemetery include Allston, Congdon, Ford, Fraser, Hazard, Lucas, Pyatt, Read, Smith, and Ward. Ivy that once covered the church's 1824 bell tower reportedly began with cuttings taken from Westminster Abbey in London.

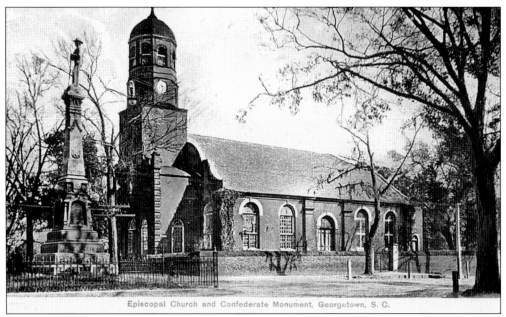

Episcopal Church and Confederate Monument, Georgetown, S. C.

Prince George, Winyah, Episcopal Church, with the Confederate monument in the foreground, is pictured about 1905. This was Georgetown's earliest substantial building, completed in 1747 and constructed of ballast brick from England, brought by a narrow waterway to the church's site at 708 Highmarket Street. Today, this church's property occupies the north side of Highmarket Street between Broad and Screven Streets. (Courtesy of Bill Benton.)

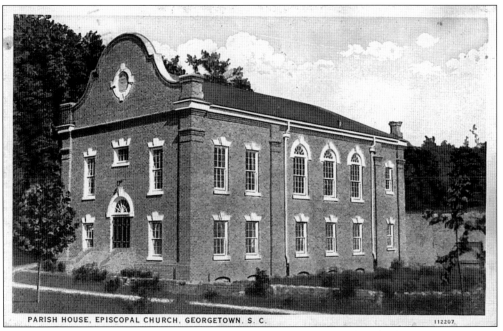

PARISH HOUSE, EPISCOPAL CHURCH, GEORGETOWN, S. C. 112207

This is the former parish hall of Prince George, Winyah, Episcopal Church, shown in 1926. Situated between the church and the current parish hall, it is now used for Sunday school classes and nursery school. (Courtesy of Ed Carter.)

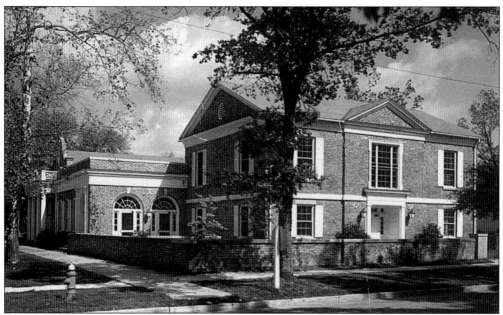

In 1953, this building at 301 Screven Street went from housing inmates, opposite page, to housing books when Georgetown County Jail relocated and Georgetown County Public Library moved from Winyah Indigo Society Hall to this building. The library is now located in a modern facility on Cleland Street, and this building was renovated in 1990 as a new parish hall of Prince George, Winyah, Episcopal Church. It is shown here about 1960.

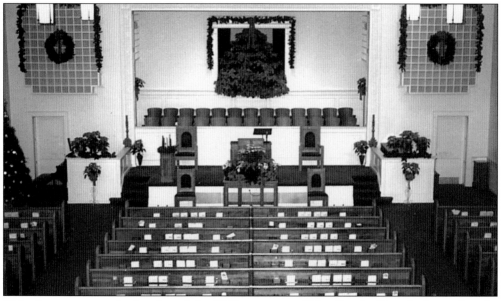

This view represents the interior of the 1949 sanctuary of First Baptist Church. Located at the corner of Cleland and Highmarket Streets, the building was razed and replaced with the present church. In order to accommodate a larger facility, the church was reoriented on its corner lot. Baptists organized in Georgetown before 1800 and previously had Antipedo Baptist Church on Church Street, at the head of Screven Street. (Courtesy of First Baptist Church.)

Georgetown County Jail occupied this building, built *c.* 1843, for over a century before it became a library, shown on the opposite page. An earlier jail was located where Bethel A.M.E. Church stands, and the present county jail is on Highway 51. As part of its conversion to a library, the jail's third story was removed and the brick wall surrounding its premises was lowered. Also during renovation, paint was removed from its exterior brick walls. Salvaged bricks were used to build the single-story addition to the back of the structure. The final result is aesthetically pleasing and bears little resemblance to the original jail. The postcard shown here was published in the late 1930s.

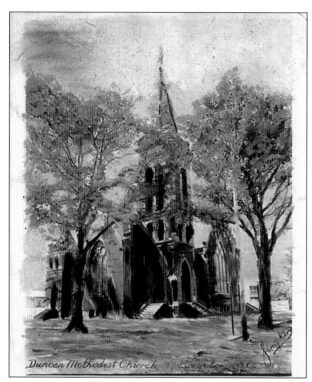

Duncan Methodist Church is seen in a rare, hand-painted 1906 postcard, made from a D.C. Simpkins photograph. Simpkins, who opened a studio in Georgetown in 1901, advertised his business as "Art Gallery, Crayon and Pastel Work, Photographs," so it is likely that the painting superimposed on this real photo postcard is also Simpkins' work. Other Simpkins photographs are shown on pages 18 and 38.

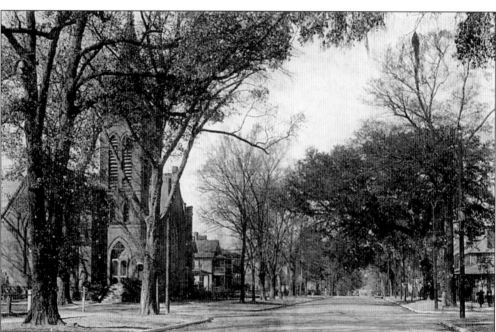

Highmarket Street, at the Orange Street intersection, is dominated by Duncan Methodist Church in this 1937 view. An earlier church and cemetery were located opposite the present building on Orange Street. Frequent surnames in the early Methodist cemetery include Croft, Easterling, Munnerlyn, Porter, Sessions, and Wilson.

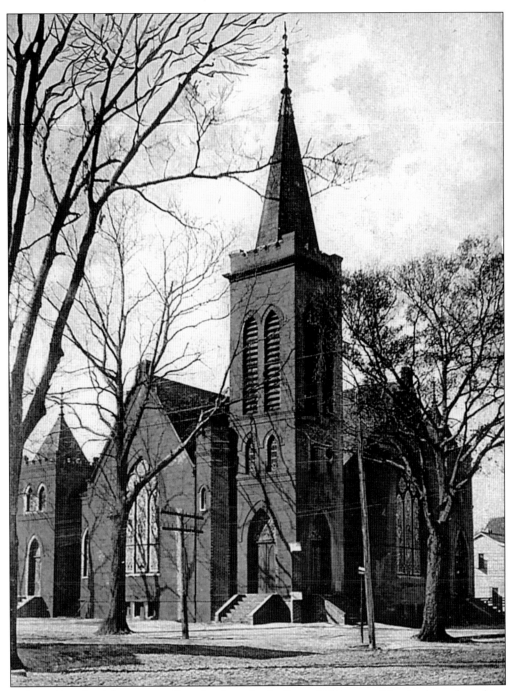

Bishop Francis Asbury, traveling by horseback from Baltimore, Maryland, and seeking converts to Methodism, met with his first success in Georgetown. Thus the oldest Methodist church in South Carolina was established in Georgetown in 1785 and incorporated in 1817. It was called Duncan Methodist Episcopal Church when this 1910 view was made. Located at 901 Highmarket Street, the church has revised its name to Duncan Memorial United Methodist Church.

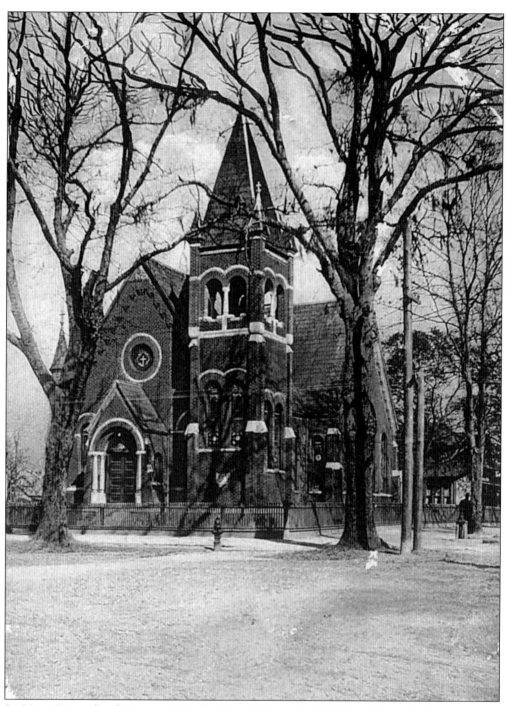

St. Mary Our Lady of Ransom Catholic Church, located at 301 Broad Street, is shown on one of Georgetown's rare snowy days in a 1910 view. Established in January 1902, the church recently celebrated its centennial with the opening of a new building, the Parish Life Center. Local Catholics held services for 40 years in Morgan family homes until this church was built, at a cost of $9,000, paid by fund-raising events and contributions. (Courtesy of Annette Coles.)

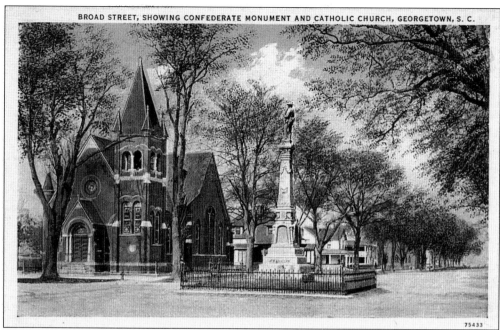

75433

This 1917 view shows the corner of Broad and Highmarket Streets when the Confederate monument dominated the intersection. St. Mary Our Lady of Ransom Catholic Church occupies the corner across Highmarket Street from Prince George, Winyah, Episcopal Church. Mayor William D. Morgan was instrumental in the building of the Catholic church during Georgetown's most rapid growth period.

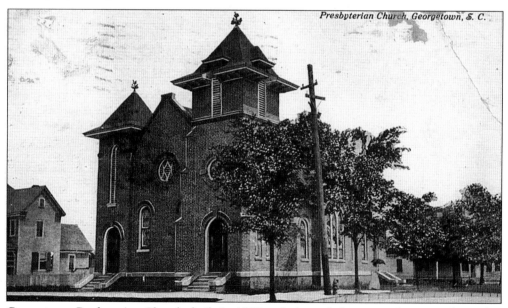

Presbyterian Church, Georgetown, S. C.

Georgetown Presbyterian Church, built in 1907 and pictured three years later, was located at 200 Winyah Road, on the corner of Hazard Street. The church was built on the site of an earlier wooden Presbyterian church destroyed in a 1906 hurricane. Georgetown Presbyterian Church is now located at 558 Black River Road. (Courtesy of Annette Coles.)

Modern Residence, Georgetown, S. C.

Heiman and Rose Kaminski occupied this imposing house on the northwest corner of Broad and Prince Streets a century ago. Kaminski was the owner of H. Kaminski and Company, retail hardware, and Kaminski Hardware Company, wholesale hardware, described below. Around 1950, the house became the local Moose Lodge, and a swimming pool was added. It was razed in 1988 and replaced with four Colonial-style townhouses. This postcard view is about 1910.

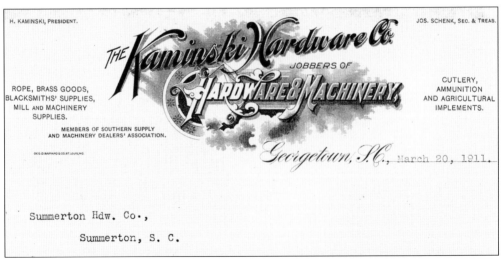

The 1911 letterhead of Kaminski Hardware Company provides insight into the local hardware business almost a century ago. Products sold included rope, brass goods, blacksmiths' supplies, mill and machinery supplies, cutlery, ammunition, and agricultural implements. This was the enterprise of Georgetown's leading Jewish merchant, Heiman Kaminski, with Joseph Schenk, serving as secretary and treasurer. Kaminski's residence is shown above.

The Jewish population has been prominent in Georgetown's history, providing the city with six mayors, three of whom served before 1818. Their synagogue, Temple Beth Elohim, built *c.* 1949 at 232 Screven Street, is located on the corner of Highmarket Street. Previous meetings were held in Winyah Indigo Society Hall. Their cemetery, one of the oldest Jewish cemeteries in the United States, dates to 1772 and is located at the corner of Broad and Duke Streets. Surnames found most frequently on grave markers in this cemetery are Benjamin, Cohen, Ehrich, Kaminski, and Sampson. Both properties are shown on this divided postcard from the 1950s.

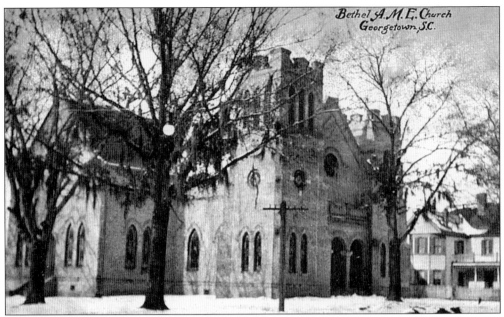

Bethel A.M.E. Church, which is on the National Register of Historic Places, is surrounded by snow sometime after its 1908 remodeling. This congregation began at Rosemont Plantation in 1865 and purchased this property in 1866. The church's education building was constructed in 1949. (Courtesy of Ed Carter.)

Bethel A.M.E. Church is part of the oldest African-American religious denomination in the United States, founded in 1787. This 1926 view shows the present church at 417 Broad Street, on the corner of Duke Street. This sanctuary, built in 1882 as a wooden church, was remodeled with brick exterior in 1908. A smaller church was previously located on the north end of this property.

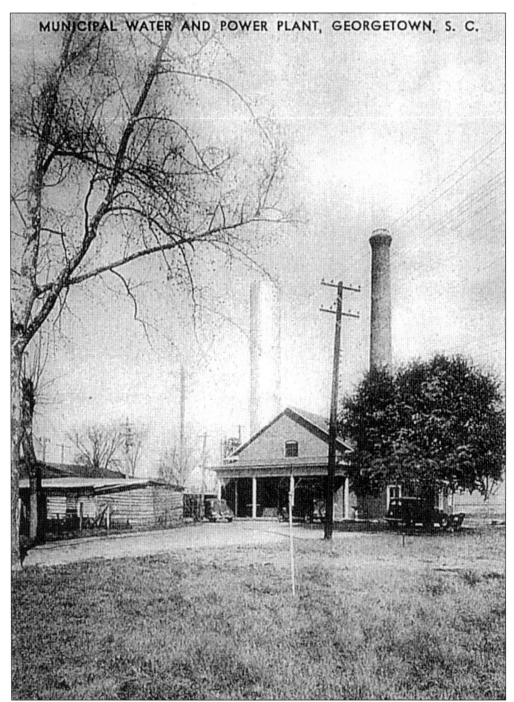

MUNICIPAL WATER AND POWER PLANT, GEORGETOWN, S. C.

Georgetown's first municipal water and power plant was built in 1902 on the corner of Prince and Fraser Streets, site of the present city hall. The water tower was dismantled in 1950; the power plant remained until the site was cleared in 1978 for city hall construction. Electricity was also supplied to Georgetown by Atlantic Coast Lumber Corporation in the early 20th century. This is a 1934 view. (Courtesy of Ed Carter.)

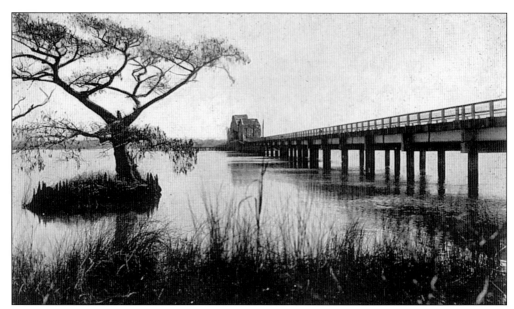

Lafayette Bridge opened in July 1935, as the final link in the U.S. 17 Ocean Highway from Maine to Florida. Built at a cost of $750,000, it was two miles long and was a toll bridge until 1937. This bridge replaced a ferry crossing and was named for the Marquis de Lafayette, freedom fighter of the American Revolution. In 1966 and 1967 separate spans of the L.H. Siau Bridge opened, replacing the Lafayette Bridge, and traversing the combined waters of the Pee Dee and Black Rivers, and the Waccamaw River. The Lafayette's steel span was recycled to bridge the Pee Dee River at Yauhannah, north of Georgetown. (Courtesy of Robert Hinely.)

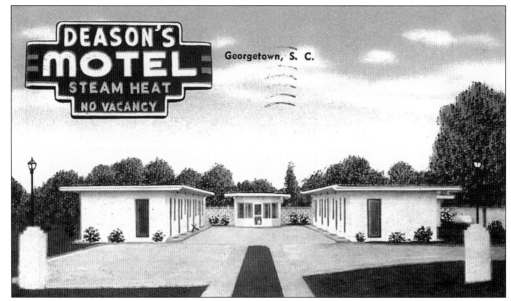

Deason's Motel, located at 412 St. James Street, was Georgetown's first modern motel and is now a Budget Inn. Its "No Vacancy" sign was changed on later postcard editions to read, "Vacancy." Owners and managers of this 22-room motel, operating from 1951 to 1979, were Marie and Descombe Deason, who also ran Deason's Restaurant on Front Street for many years.

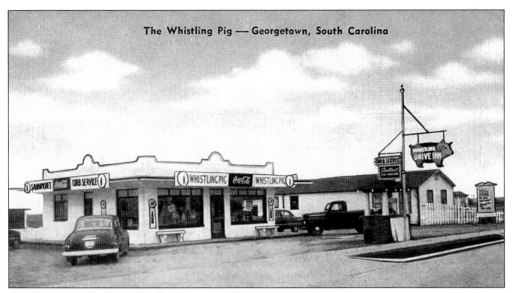

The Whistling Pig — Georgetown, South Carolina

A chili hotdog at The Whistling Pig, 402 Church Street, was said to be the first wish for many of Georgetown's returning World War II soldiers. This landmark teenage drive-in, pictured in 1950, was owned and operated by Jim P. Skinner, who also ran Lafayette Cottages and a Sinclair Gas station, all clustered together at the foot of Lafayette Bridge. Now remodeled, this building is the realty office of The Georgetown Agency, with a sentry from its past at the front door, a concrete pig!

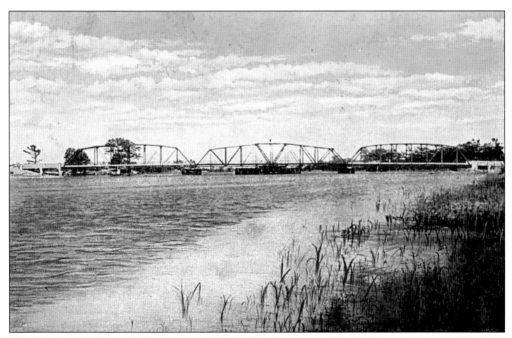

The first Sampit River bridge was a swing bridge that opened in 1926, to replace a cable ferry. Today, a concrete arch, named the Sylvan L. Rosen Bridge, spans the Sampit, reportedly South Carolina's shortest river. Depending on whom one consults, it is 6, 9, or 11 miles long. Both navigational and geographical distances vary over time. (Courtesy of Ed Carter.)

Black River Road was a dirt trail traveling past abandoned rice fields when this real photo postcard was made a century ago. Today, this heavily traveled area is the address of Georgetown Memorial Hospital, Georgetown Presbyterian Church, businesses, and residences. Black River Road now forms Highway 51 to Rhems.

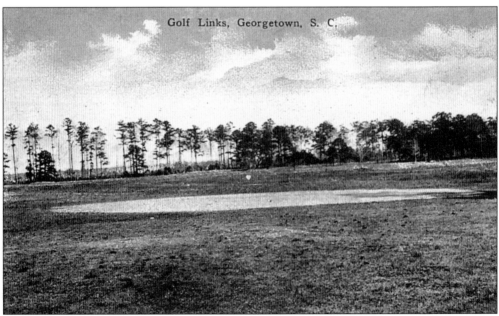

Golf Links, Georgetown, S. C.

This water trap must have frustrated many a Georgetonian learning to play golf almost a century ago. Georgetown Golf Club no longer exists, but area golf courses are plentiful. The oldest is Winyah Bay Golf Club, established in 1955. Golf courses and surrounding residential housing are the economic fuel of many area plantations, including Caledonia, Hagley, Litchfield, True Blue, Wachesaw, Willbrook, and Wedgefield. (Courtesy of Ed Carter.)

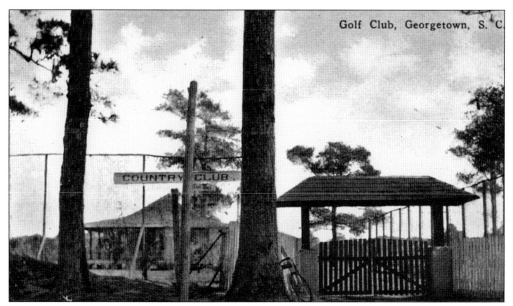

Georgetown Golf Club, established in 1905, had the distinction of being the second oldest golf course in South Carolina; the oldest was Charleston Country Club. Entered from Fraser Street, it extended to Star Route 1. Sadly, this golf and tennis club is no more, having been redeveloped as commercial and residential property. However, golf courses abound in the Georgetown and Waccamaw Neck area, now recognized internationally as part of the Grand Strand golf mecca. (Courtesy of Curt Teich Postcard Archives.)

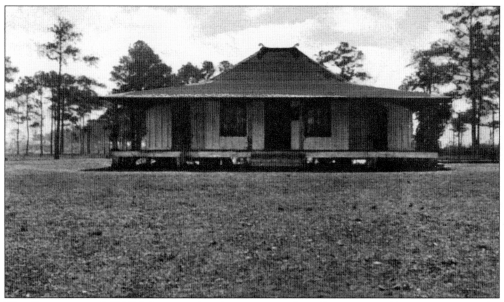

The Georgetown Golf Club house, minus its wraparound porch, was moved in recent years to the corner of Pyatt and Horry Streets. Its original site was near the present corner of North Fraser and Charlotte Streets. Low brick borders defining the entrance at the club house's original location were provided in the 1930s by Col. Robert Montgomery of nearby Mansfield Plantation, where similar brickwork is evidenced. (Courtesy of Curt Teich Postcard Archives.)

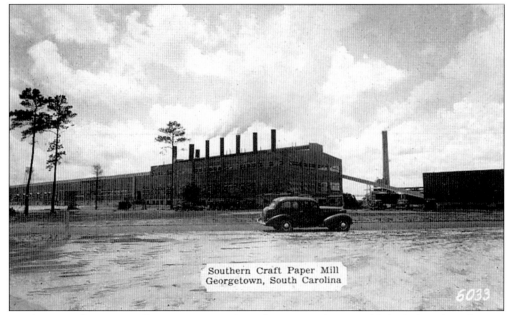

Southern Craft Paper Mill
Georgetown, South Carolina

6033

Southern Kraft Paper Mill was so new when this postcard was published that the salesman misspelled its name. The mill opened in 1937 on a 525-acre site on the Sampit River and was heralded locally as an exit from the Great Depression. Originally costing $75,000, it has undergone several expansions, seen on these two pages, and is now called International Paper Company's Georgetown Mill.

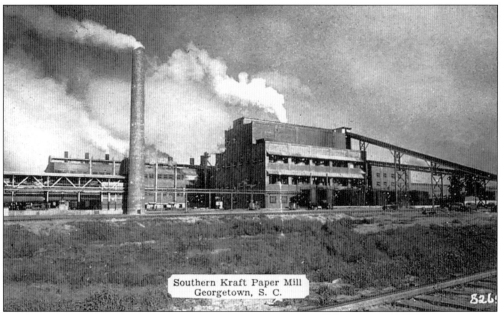

Southern Kraft Paper Mill
Georgetown, S. C.

826

Located at the end of South Kaminski Street, Southern Kraft Paper Mill is seen after its third and largest paper machine began production in February 1942. It became, at that time, the world's largest kraft paper mill, producing 1,350 tons of board daily. Kraft paper, kraft container board, and bleached kraft are all products of the Georgetown mill.

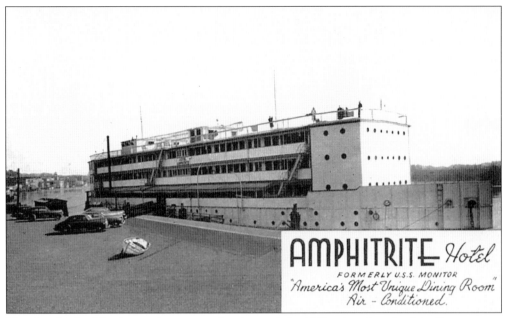

The Amphitrite Hotel must have created quite a stir in 1946 when it arrived in Georgetown. This 85-room floating hotel docked at the terminus of Wood Street until 1949, when the U.S. government recalled its service. It was a battleship, begun in the 1870s and completed about 1890, that was active in the Spanish American War and both World Wars. It came to Georgetown with the encouragement of International Paper Company, needing convenient, temporary housing, and it stayed to entertain local citizens with its showboat performances and restaurant.

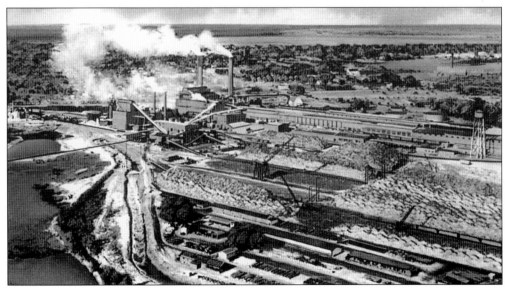

This aerial view was taken west of International Paper Company's Georgetown mill, showing the city in the background, about 1948, the year that I.P.C. celebrated its 50th anniversary. Southern Kraft was the name of its southeastern U.S. division, with kraft meaning "strength," as applied to its paper products.

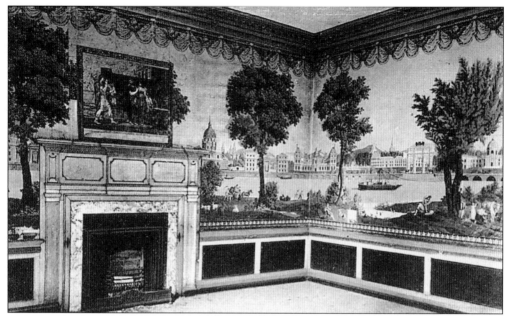

The drawing room of Friendfield Plantation was the height of elegance in 1824. Shown following a long vacancy, it retains hand-painted wallpaper imported from France, and wainscoting and mantle befitting a mansion. This plantation house was immediately admired for the expensive tastes of owner Francis Withers, which included marble fireplace surrounds and silver doorknobs. The restored Silver Hill Plantation, built *c.* 1791, is also part of this property and features formal gardens designed by landscape architect Jean Rothrock.

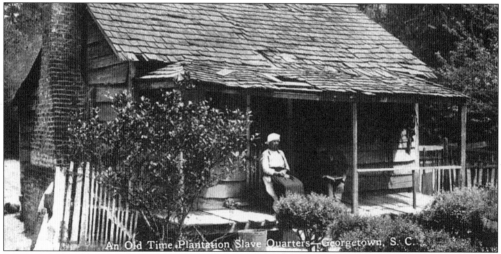

An elderly African-American couple sits on the porch of this one- or two-room cabin, typical of slave quarters on many area plantations. The location of this postcard view is identified only as "Georgetown, S.C." The card was published by Seaboard Air Line Railway, which purchased the Georgetown and Western Railroad. Freed slaves sometimes remained on plantations, working for low wages. Slave descendants lived in quarters at Mansfield Plantation until 1990. A settlement of African Americans remains at Arcadia Plantation, where slave quarters once stood for the residents' ancestors.

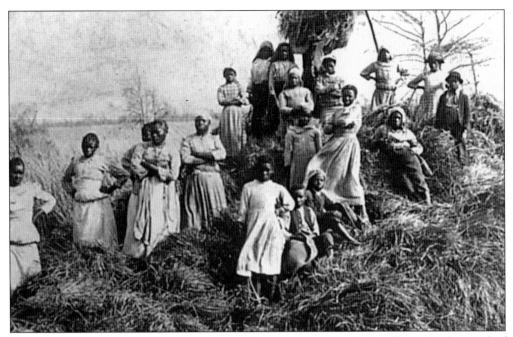

A rice barge loaded with rice straw and field hands is photographed before a background of rice fields in this 1895 stereoview. Most likely taken on a Sampit River plantation, this image is described as depicting a scene west of Georgetown. From the facial expressions on these African Americans—mostly women and children—one sees that they are not happy to be photographed. Tired from a day of harvesting rice, they appear anxious to return home.

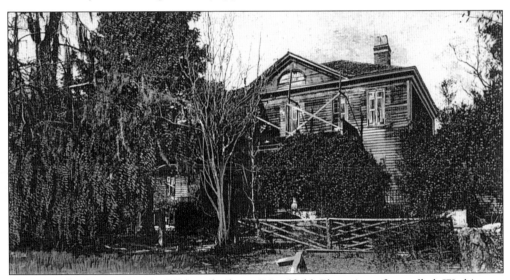

This was the house Francis Withers built at Friendfield Plantation, first called Washington Plantation, on the Sampit River in 1818. Withers, who was born in an earlier house on this land grant property and educated at Harvard, owned multiple Sampit River plantations and houses in Georgetown. Postmarked 1909, this card shows Friendfield prior to its 1919 restoration, which was enjoyed for only seven years before the house burned. It was rebuilt in 1931, and the property is a National Register of Historic Places district. (Courtesy of Annette Coles.)

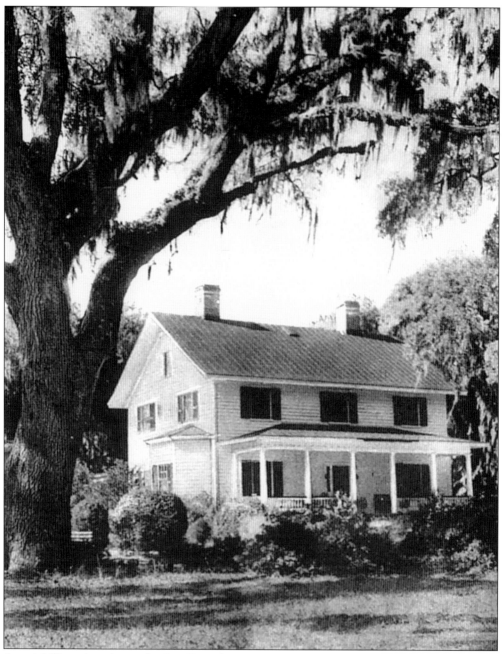

Arundel Plantation sits on the Pee Dee, the river mentioned by Steven Foster in the first line of his Southern ballad, *Old Folks at Home,* later revised to "Swanee" river. Arundel's name derives from Arundel Castle in England, and Gothic outbuildings distinguish it from other area plantations. This house, the second on the property, was built over a 50-year span, beginning in 1841. The title passed through multiple ownerships in the 19th century, ending in 1904 when James Louis LaBruce acquired Arundel and held it in his family for 50 years. A two-story piazza replaces the one seen in this 1950s view. This plantation is in the Pee Dee River Rice Planters Historic District of the National Register.

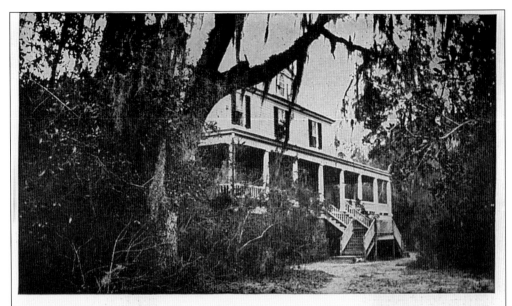

For Sale Chicora Wood Plantation, Georgetown Co., S.C.

Chicora Wood Plantation, on the Pee Dee River, was previously named Mantanzas. This was the home of Elizabeth W. Allston Pringle, author of *A Woman Rice Planter* and *Chronicles of Chicora Wood*, and her father, Robert Francis Withers Allston, a South Carolina governor from 1856 to 1858. This is a 1922 view of Chicora Wood, when the house and surrounding 900 acres was for sale. Now restored, it is a National Register of Historic Places property within the Pee Dee River Rice Planters Historic District of the National Register.

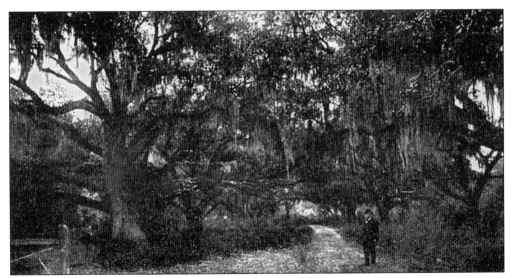

Weehaw was a Black River plantation belonging to the Cleland family, acquired by Francis Kinloch through marriage in 1751, and passed to his children. It was located on the Black River between Windsor Plantation and Kensington Plantation. In this postcard view, an elderly man stands in a dirt road beneath live oaks draped with Spanish moss, presumably at the plantation entrance road. (Courtesy of Bill Benton.)

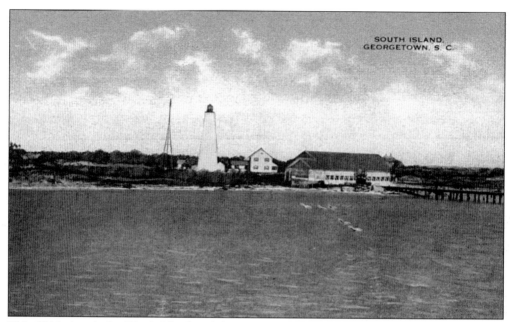

This 1914 view is the North Island Lighthouse, also called the Georgetown Lighthouse, which was erroneously attributed on this postcard to South Island. Located on the southern end of North Island near Winyah Bay's entrance, this lighthouse, established in 1812, is a National Register of Historic Places building. The large building is a dance pavilion. North Island's 4,500 acres are within the Tom Yawkey Wildlife Center, explained below. In 1986, this light was converted to automated operation. (Courtesy of Curt Teich Postcard Archives.)

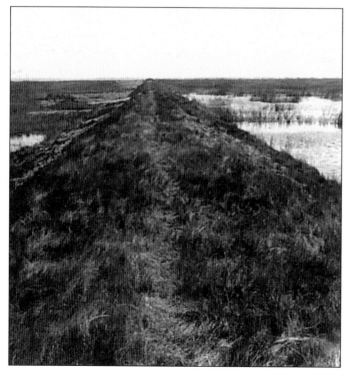

This stereoview is labeled, "Looking E. on great government dike on coastal plain, Georgetown, S.C." This earthen dike, nine feet high and over two miles long, was built to anchor the South Island jetty started in 1898 at the mouth of Winyah Bay. The property is now part of the Tom Yawkey Wildlife Center, bequeathed to the S.C. Wildlife and Marine Resources Department in 1976 by Yawkey, owner of the Boston Red Sox. The center includes North Island, South Island, and most of Cat Island, or about 31 square miles of barrier island and mainland habitats.

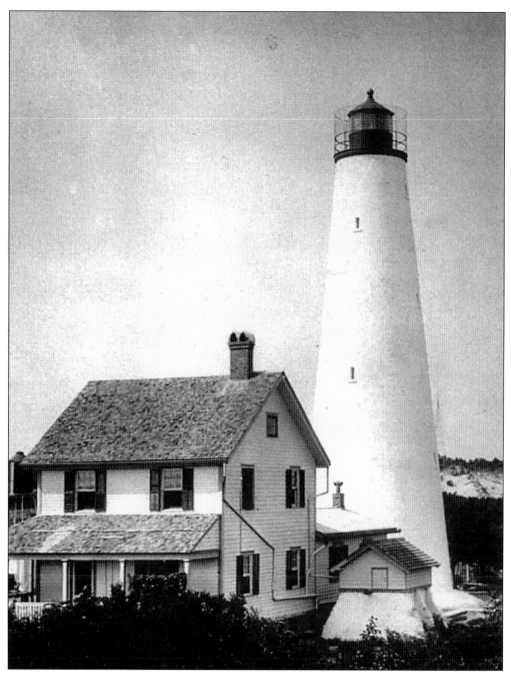

North Island Lighthouse, shown in 1921, is closely associated with the Hurricane of 1822, when it was the only surviving North Island structure of that storm. In fact, the island was almost entirely under water! A village surrounding the lighthouse washed away, along with its 125 inhabitants. During the Civil War, the light was extinguished but has otherwise operated continuously since its construction. This area and Fraser's Point on Hobcaw Barony were occupied by Confederate troops protecting Winyah Bay and Georgetown during the war. (Courtesy of Georgetown County Public Library.)

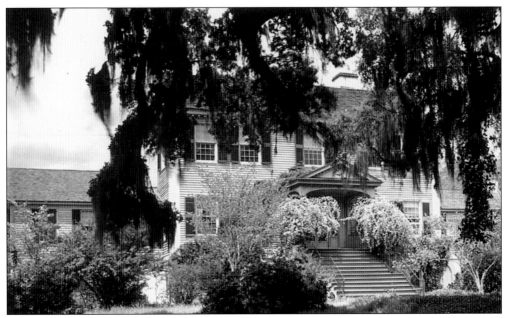

Belle Isle Plantation was the site of Gen. Francis Marion's childhood home and the location of the earthen fortress, Battery White, which was captured by Federal troops during the Civil War. Battery White and Belle Isle's rice mill chimney, located near Black Out Plantation on Cat Island, are both listed on the National Register of Historic Places. Gen. Peter Horry, for whom the adjoining Horry County is named, named Belle Isle when he owned it as part of his larger Dover Plantation holdings 200 years ago. Belle Isle now contains a residential subdivision.

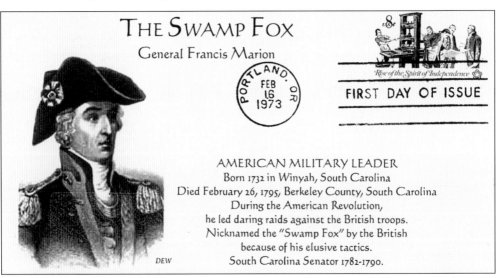

Gen. Francis Marion, widely known as the "Swamp Fox," was honored by the U.S. Postal Service with this First Day Cover, issued February 16, 1973. Marion's legendary fame resulted from the romanticized book, *The Life of General Francis Marion*, published in 1824 by Mason L. Weems and based on the Revolutionary War journal of Marion's friend and lieutenant commander, Gen. Peter Horry. Historical accuracy was not Weems's style; he is credited with the fictitious story of George Washington chopping down a cherry tree.

Belle Isle Plantation views Winyah Bay and the site where the U.S.S. *Harvest Moon* sank on February 28, 1865. Crew reports indicate Adm. John Dalgren's flagship sank in five minutes in two-and-a-half fathoms of water, after impacting a Confederate mine built in a Georgetown store by Thomas West Daggett, referenced on page 14. Extreme low tides sometimes reveal the *Harvest Moon*'s smokestack, causing one to wonder if it could be raised to become Georgetown's answer to the famed *Hunley*, Confederate submarine.

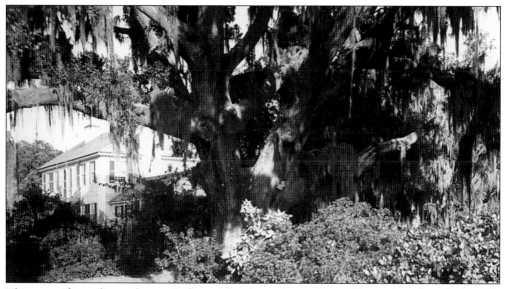

This magnificent live oak tree is framed by the azalea and camellia gardens for which Belle Isle Plantation has been well known. The house seen in this 1940 postcard was dismantled in Newberry, South Carolina, and rebuilt at Belle Isle under the guidance of Mrs. Henry Sage, who leased Belle Isle for 10 years. Afterwards, property owners Mr. and Mrs. Frank E. Johnstone lived here until the house burned in 1942.

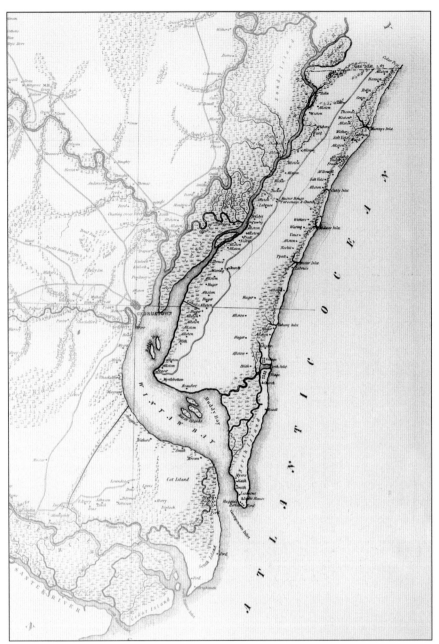

This Waccamaw Neck map was excerpted from the 1825 Georgetown District map on page 2. This "neck" of land varies in width from 2 to 14 miles. Listed on the map are the 1825 surnames of ownership, almost half of which are Allston or Alston. One brother dropped an "l" from his name to distinguish himself from relatives. Change came slowly to this area until recent decades, when development has seemed intent on eclipsing the remainder of the Grand Strand. In 1930, the only public school on Waccamaw Neck was a one-room school at Waverly Mills taught by Mrs. Marie L. Ward. Pawleys Island has changed the least, but one notes that the name originally designated an area east of the island's salt marsh; now its geographic boundaries encompass a large mainland area west of the island.

Two

WACCAMAW NECK

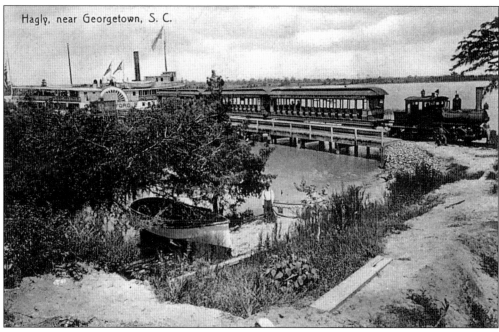

Hagly, near Georgetown, S. C.

The *Governor Safford* side-wheeler arrives from Georgetown and docks at Hagley Landing on the Waccamaw River, where passengers transfer to the awaiting Georgetown & Pawleys Island Railway to complete their journey to the island. Atlantic Coast Lumber Corporation purchased Hagley Plantation a century ago and built this landing to facilitate employees living in company housing on the island and commuting to work at A.C.L. The train was provided by the lumber corporation from 1902 until 1906, when a hurricane destroyed its rails.

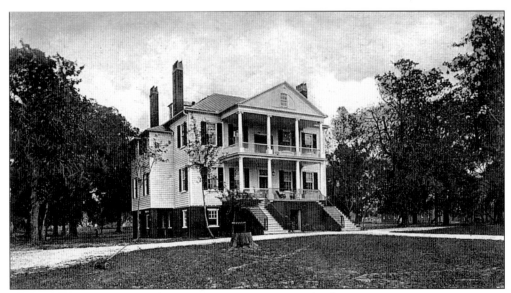

Arcadia Plantation was named during its 1906–1931 ownership by Dr. Isaac E. Emerson, inventor of Bromo Seltzer, to describe his consolidation of the following plantations: Oak Hill, Fairfield, Prospect Hill, Clifton, Forlorn Hope, Rose Hill, and portions of Bannockburn Plantation. This was previously the main house of Prospect Hill Plantation, built *c.* 1794 by Thomas Allston to resemble his older brother's nearby home, Clifton Plantation, which burned. President James Monroe visited here in 1821 as the guest of owner Benjamin Huger Jr. Emerson enlarged the house shown above and added a conservatory to this National Register of Historic Places property. (Courtesy of Annette Coles.)

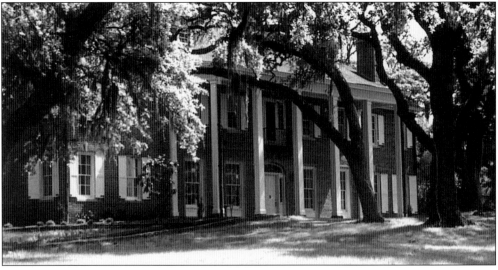

Hobcaw House, built in 1930, is a landmark on the 17,500 acres contained in Hobcaw Barony, the consolidation of 10 rice plantations near Georgetown by distinguished American statesman and Wall Street financier Bernard Baruch. The Camden native exceeded his goal of restoring this property to the original 12,000-acre barony granted by the Lord's Proprietors. Famous guests of Hobcaw House during Baruch's ownership included President Franklin D. Roosevelt, Winston Churchill, Irving Berlin, Jack London, and Gen. Mark Clark.

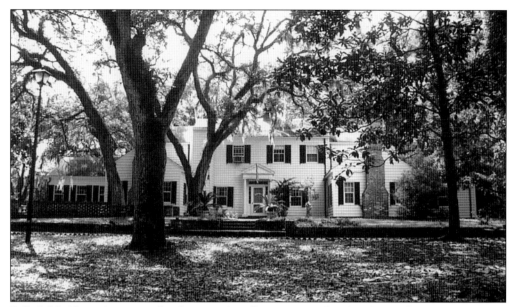

Bellefield Plantation was the home of Belle W. Baruch, daughter of Bernard Baruch. Also situated on Hobcaw Barony, this house takes its name from an earlier plantation on the property. Located north of Georgetown on Highway 17, Hobcaw Barony now belongs to the Belle W. Baruch Foundation, which maintains a public museum, Hobcaw Barony Visitor Center, and provides university research facilities. "Hobcaw" is an Indian word meaning "between the waters."

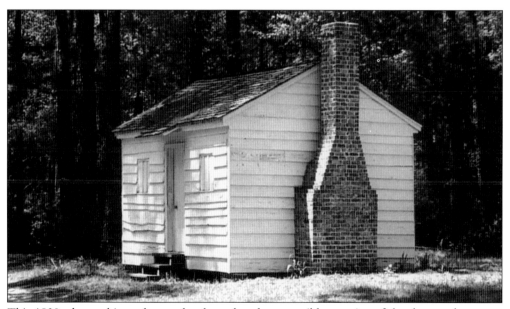

This 1830s slave cabin and a nearby slave chapel are tangible remains of the slave settlement at Friendfield Plantation in Hobcaw Barony on Winyah Bay. The plantation's Victorian house, affectionately called "the Relic," burned during Christmas holidays in 1929, while owner Bernard Baruch was hosting guests there. A replacement, Hobcaw House, opposite page, was built in 1930 of concrete, steel, and brick, in an attempt to create a fire-resistant home.

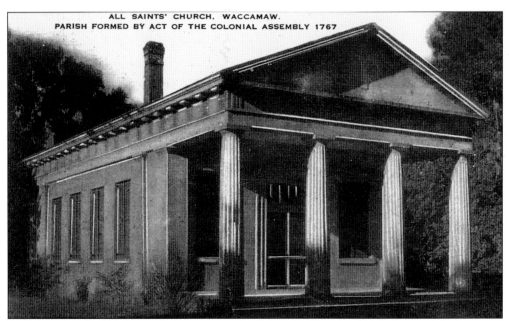

All Saints' Parish, Waccamaw Episcopal Church is a National Register of Historic Places district on Waverly Creek and was one of the Episcopal Church's wealthiest rural parishes prior to the Civil War. This church now occupies its fifth sanctuary. The parish was established in 1767 and had in its membership leading Waccamaw Neck rice planters, including Joshua John Ward of Brookgreen Plantation and Plowden C.J. Weston of Hagley Plantation.

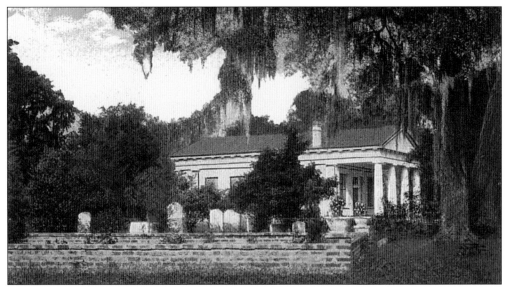

This 1930 postcard shows All Saints' Parish, Waccamaw Episcopal Church and cemetery. Its most famous grave bears one word, "Alice," and is reputed to be the burial site of Murrells Inlet's legendary Alice Flagg. Surnames appearing on grave markers most frequently include Allston, Alston, Flagg, Fraser, LaBruce, Lachicotte, Pawley, Ward, and Weston. Many plantations had private cemeteries for family burials and separate slave cemeteries. This postcard was sold at Lachicotte's Mercantile Store.

This postcard depicts an African–American baptism service held in the 1920s at Midway Inlet, on the southern end of Magnolia Beach, now Litchfield Beach. In the 1940s, 40 acres of former "heir property," so named because it was owned by descendants of slaves without formal title, was sold and developed as McKenzie Beach. Co-owner Frank McKenzie led development of this popular segregated beach for African Americans, which was destroyed by Hurricane Hazel in October 1954.

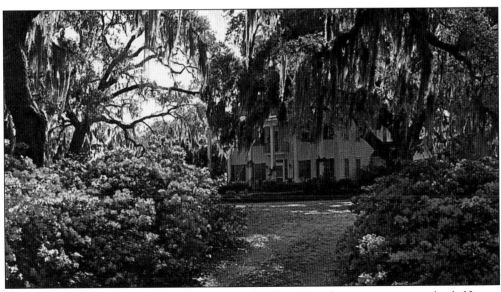

Rossdhu Plantation, also called Lower Waverly Plantation, began as a one-and-a-half-story house built a century ago by St. Julian Lachicotte and sold in 1938 to Capt. William Ancrum of Camden. Ancrum renamed it for his ancestral home in Scotland, Rossdhu. Architectural revisions by successive owners enhanced the appearance of this Waccamaw River plantation, created by a division of Waverly Plantation, which predates 1750. In 1871, Phillip Rossignol Lachicotte bought Waverly from the Allston family, and developed Waverly Mills, a large commercial rice milling operation.

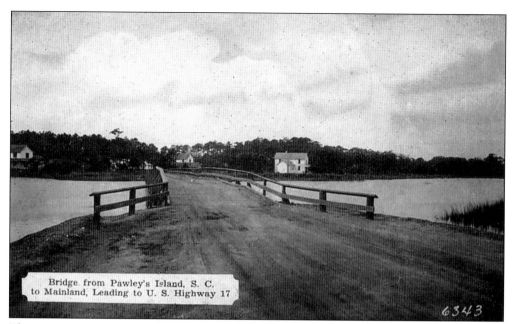

Bridge from Pawley's Island, S. C.
to Mainland, Leading to U. S. Highway 17

6343

These two views reflect the modernization of the North Causeway bridge to Pawleys Island. Above is a 1930s view of the wooden bridge connecting a dirt road with the island. Below is a concrete bridge linking a paved road with the island. Originally, two bridges were required to access the island; one was eliminated by partially filling the marsh. The resulting poor drainage of the creek is causing its gradual filling with silt.

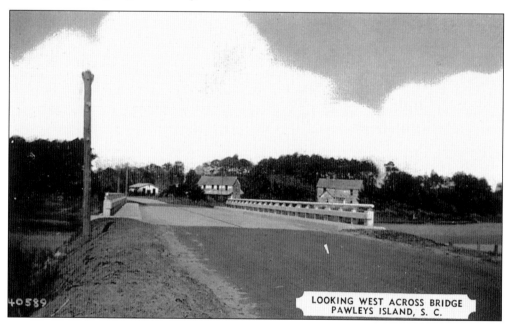

40589

LOOKING WEST ACROSS BRIDGE
PAWLEYS ISLAND, S. C.

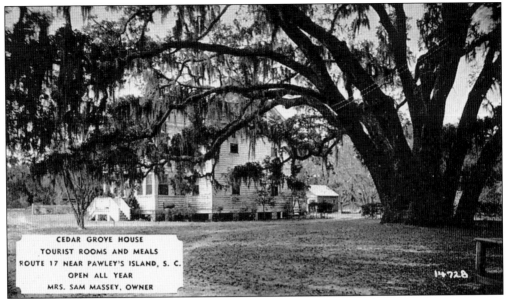

CEDAR GROVE HOUSE
TOURIST ROOMS AND MEALS
ROUTE 17 NEAR PAWLEY'S ISLAND, S. C.
OPEN ALL YEAR
MRS. SAM MASSEY, OWNER

Prior to the Civil War, Cedar Grove house on the north end of mainland Pawleys Island was the residence of Dr. Andrew Hasell, an English physician whom local planters hired to provide medical attention to their families and slaves. Hasell also ran a small school on this property, teaching industrial arts to slaves from nearby plantations. Although sometimes called a "plantation," this antebellum estate never grew a commercial crop. It is shown in the 1940s, when it was a boarding house, purchased by Bernard Baruch and given to his groundskeeper upon retirement. (Courtesy of Burroughs and Chapin Company.)

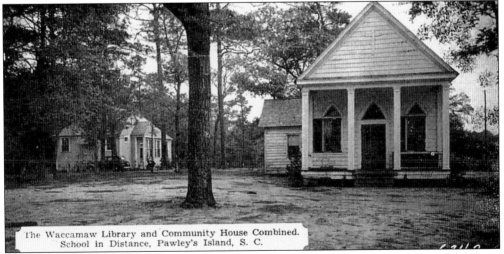

The Waccamaw Library and Community House Combined.
School in Distance, Pawley's Island, S. C.

This slave chapel on Cedar Grove property was donated to All Saints' Parish, Waccamaw Episcopal Church, with an acre of surrounding land. It became a summer chapel, or chapel of ease, for nearby residents. In 1935, when Highway 17 construction traversed this property, the chapel was relocated beside the new highway. It was later moved to All Saints' Parish, Waccamaw Episcopal Church property, where it remains, once serving as Waccamaw Library and Community House. One of three remaining slave chapels among 13 built on the Waccamaw Neck, this is a National Register of Historic Places property.

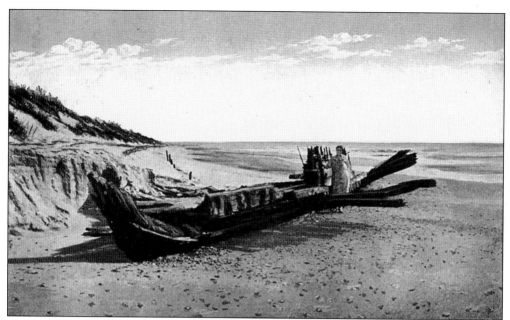

The hull of a small ship believed to be of 19th century origin was exposed on the beach in front of the Pelican Inn over 70 years ago. Locals called it "the wreck," but its past remained a mystery. This postcard of the ship's skeletal remains was sold at Lachicotte's Mercantile Store and postmarked Waverly Mills in 1936, shortly before that community post office closed.

Rusty Ann Lodge, pictured in 1951, was located on Highway 17 at Pawleys Island. Managed by Bunny and Lyle Vivrette, this log cabin lodge appealed to sportsmen by advertising to arrange hunting and fishing parties. "Fine hunting and fishing" is how the postcard describes the Waccamaw Neck, adding that the lodge serves "superb" food.

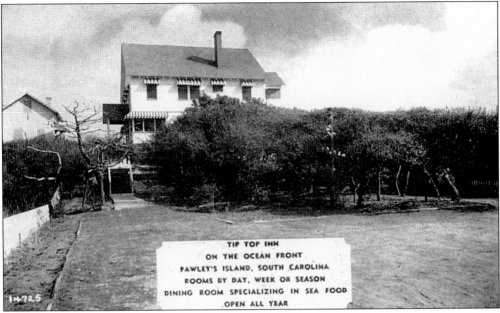

TIP TOP INN
ON THE OCEAN FRONT
PAWLEY'S ISLAND, SOUTH CAROLINA
ROOMS BY DAY, WEEK OR SEASON
DINING ROOM SPECIALIZING IN SEA FOOD
OPEN ALL YEAR

Tip Top Inn, shown above and below, was one of a half dozen Pawleys Island boarding houses in the 1940s, when these views were taken. It was located north of the island's first dance pavilion, which closed in 1925. Mr. and Mrs. Robert S. Dingle, formerly employed at Arcadia Plantation, were the owners and managers of Tip Top, beginning in 1940. It was razed in 1989 following Hurricane Hugo. Other beach house hotels through the decades have included Pelican Inn, Ellerbe House Inn, Newcastle, Sea View Inn, and Cassena Inn, the last two of which are shown on the following page. (Courtesy of Burroughs and Chapin Company.)

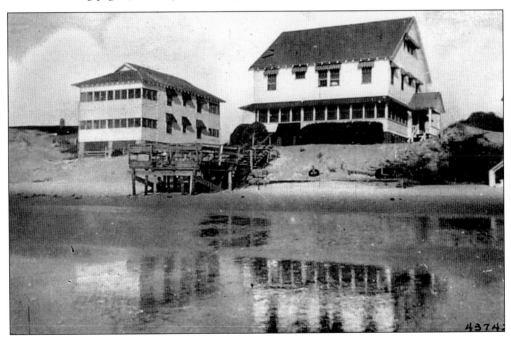

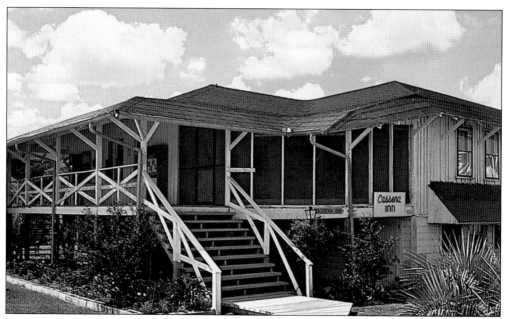

The Cassena Inn was run for 18 years by Mrs. Mina Hope and Mrs. Gladys Hiott, serving breakfast and dinner daily. Around 1952, they also opened a local cafeteria, so popular that they couldn't maintain its operation. They wrote a cookbook instead, entitled *Potluck from Pawleys*. When these owners retired, they turned the inn's operation over to Buddy and Roberta Prioleau of Columbia. (Courtesy of Burroughs and Chapin Company.)

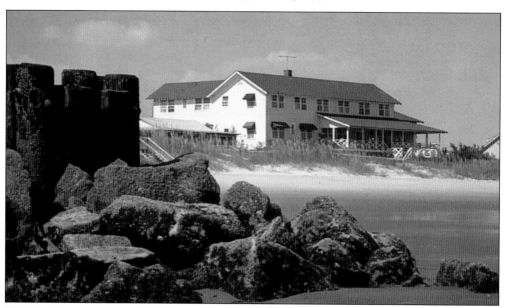

The Sea View Inn, 414 Myrtle Avenue, was started in 1937 by a Duke University math professor and his wife, the Klinkscales. It is a nostalgic hotel serving three meals daily in its old fashioned dining room. Twenty guest rooms, without television or air conditioning, are also reminiscent of yesteryear. This building, located on one of the island's highest elevations, collapsed onto nearby dunes during hurricane Hazel in 1954. Carefully rebuilt, it continues to serve guests.

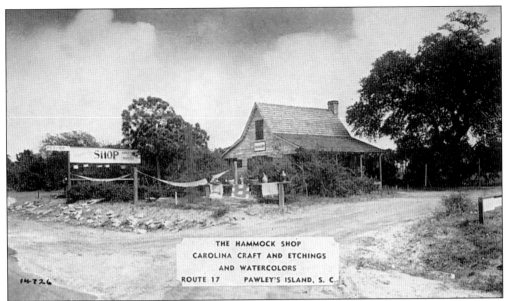

THE HAMMOCK SHOP
CAROLINA CRAFT AND ETCHINGS
AND WATERCOLORS
ROUTE 17 PAWLEY'S ISLAND, S. C.

Arthur Herbert Lachicotte began the Hammock Shop in a small building beside Tamerish, his family beach house on Pawleys Island. Concern about hurricane exposure prompted Lachicotte in 1938 to relocate his hammock and gift business to its current Highway 17 site, previously part of Cedar Grove property. This store was the first of many historic-looking buildings constructed at the Hammock Shop Complex, traditional focal point of the Pawleys Island commercial district. Its original product is the world-famous Pawleys Island rope hammock, invented by Capt. Joshua John Ward.

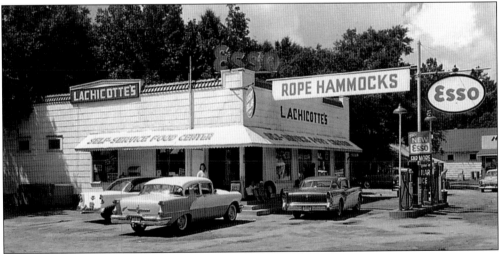

The first Lachicotte's Mercantile Store was located on the north side of the North Causeway and was abandoned after 1943. A second Lachicotte Mercantile Store was originally located about 100 yards from the North Causeway bridge. Operated by "Cap'n Bill" Lachicotte, this store was dismantled in the early 1960s and moved to the location pictured above, at the intersection of Highway 17 and the North Allston Causeway. Lachicotte's store closed in the late 1960s, and the building became a Foodland store, which later burned. It is now the site of Pawleys Island Supplies, selling hardware.

Pawleys Island Pavilion, pictured about 1964, was called the "new" pavilion when it was built over North Causeway marsh in 1960. It replaced the "old" pavilion, also called the Lafayette Pavilion, which burned around 1958. Alas, on June 16, 1970, the same fate destroyed this popular dance pavilion. Memories of shag dancing, summer romances, and carefree youth spent here are renewed annually at the Pawleys Island Pavilion Reunion, a beach music celebration gaining momentum.

Thirty-foot high dunes were once common on Pawleys Island, as shown in this 1931 view, entitled "Pawleys Island, Front Beach, Waverly Mills, S.C." The island's name derives from Percival Pawley, whose 1711 land grants included Waccamaw River property in the Pawleys Island area, inherited by his three sons, George, Anthony, and Percival. Wealthy area rice planters who had beach houses on Pawleys Island included Robert F.W. Allston of Chicora Wood Plantation, Joseph Blyth Allston of Waverly Plantation, Plowden C.J. Weston of Hagley Plantation, Joshua John Ward of Brookgreen Plantation, brothers Joshua and John LaBruce of Oak Hill and Grove Hill Plantations, and Maj. Robert Nesbit of Caledonia Plantation. Surviving historic houses constitute the island's National Register of Historic Places district.

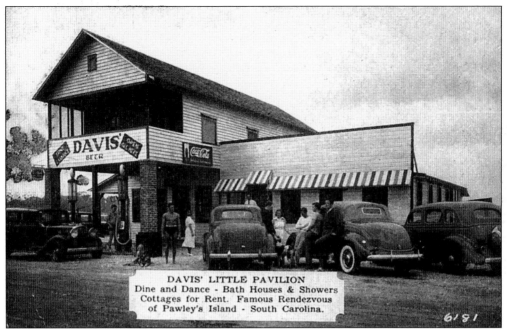

DAVIS' LITTLE PAVILION
Dine and Dance - Bath Houses & Showers
Cottages for Rent. Famous Rendezvous
of Pawley's Island - South Carolina.

Davis' Store and Little Pavilion was known for its cheap apple wine and rowdy atmosphere after dark. Youthful alcohol consumption was of less concern in 1939, when this postcard was mailed, and Davis' Pavilion was a rocking place, with a new dance called the Big Apple. Other island hangouts of the 1930s included The Towers, with its private booths, and the "old" pavilion, or Lafayette Pavilion, both of which burned, the latter around 1958. Music at the "old" pavilion was provided by a Victrola.

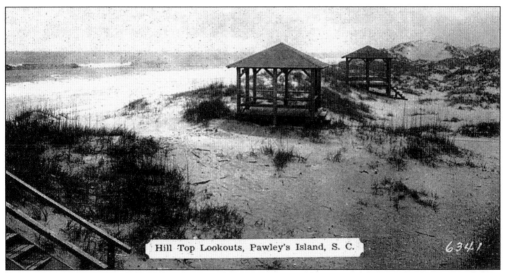

Hill Top Lookouts, Pawley's Island, S. C.

Hill top lookouts, or cabanas, were usually lined with bench seating and built over the primary sand dune, where their elevated perspective and cooling breeze made them inviting places to spend time with a friend or a book, or just to contemplate life. Most beachfront island houses had a lookout, which was also useful for locating stray children, sipping a drink, or both, all in time for a fresh seafood dinner, prepared back at the house.

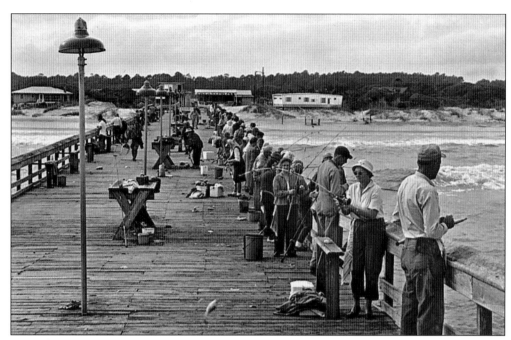

It isn't hard to guess on which side of the pier fish were biting in this 1950s view of Pawleys Island Fishing Pier. Built around 1945, this pier aligns with the North Causeway to the island, which is four miles long and one-fourth of a mile wide.

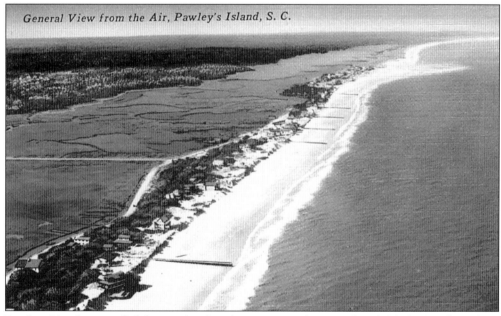

General View from the Air, Pawley's Island, S. C.

Pawleys Island appears lightly populated in this 1940s aerial view. Identifiable landmarks include the North Causeway road and groins along the beach. Known as the "arrogantly shabby" beach, this island's first families built their summer homes on the mainland side of the creek, later relocating onto the island itself. In a small cemetery on the South Causeway mainland are the graves of several early inhabitants.

The brick entrance gates to Litchfield Plantation are shown on a 1931 postcard sold by Lachicotte Mercantile Company. This is thought to be one of the area's oldest plantation houses, documented in 1794, and later enlarged to its present size. The main house now serves as an inn for the golf course and residential community surrounding it. The family most closely associated with Litchfield was the Tucker family, who owned it throughout the 19th century.

Litchfield Plantation, glimpsed in the distance, is the only Waccamaw Neck plantation remaining with an entrance avenue of live oaks. This was a river-to-sea plantation, which basically retained the integrity of its dimensions until the last half of the 20th century. South Carolina's first canning factory, owned by Louis Claude Lachicotte, was started here in 1890. Seafood and vegetables were canned with the brand name of Breslauer, Lachicotte and Company.

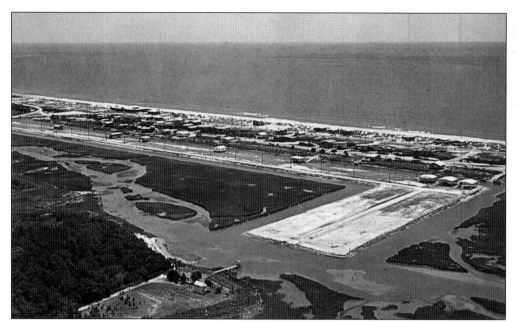

Litchfield Beach was established in the 19th century as Magnolia Beach. Its southern end became a segregated beach for African Americans in the decades before Hurricane Hazel in 1954 and is shown on page 81. This aerial view illustrates the development of its channel lots, created by dredging and filling the marsh. The broad, sandy delta is filled land, previously part of the surrounding marsh.

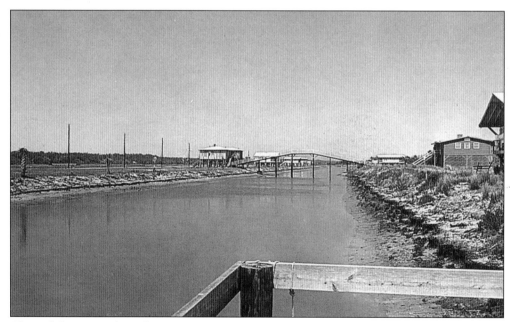

Channel lots providing direct water access to homeowners were a developmental feature of Litchfield Beach, which began in 1959. Environmental impact studies later resulted in the discontinuation of many dredging practices. The centerpiece of Litchfield Beach, located almost midway between Georgetown and Myrtle Beach, is its oceanfront hotel, Litchfield Inn.

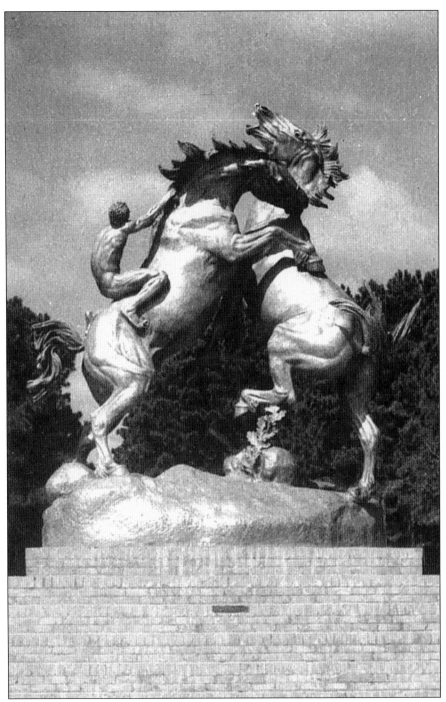

Anna Hyatt Huntington's *Fighting Stallions*, created in 1950, is cast in aluminum 15 feet high and has become an icon for Brookgreen Gardens. The sculpture is appropriately stationed at the entrance gates on Highway 17 and beckons visitors into the National Register of Historic Places district. Inside, the gardens form a natural stage upon which is displayed the country's finest outdoor collection of American sculpture.

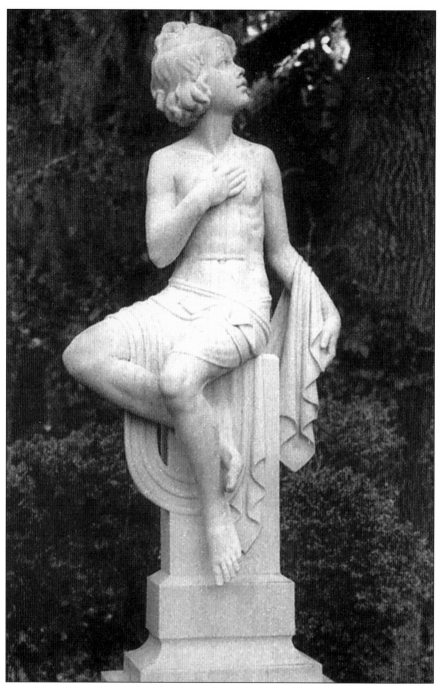

The Moonbeam was executed in 1937 by sculptor Abram Belskie, born in 1907. As Brookgreen Gardens was developed, the original plan to display Anna Hyatt Huntington's sculpture was soon broadened to incorporate the works of other artists. The resulting extensive sculpture garden is undoubtedly grander than the Huntingtons envisioned. They incorporated the gardens with non-profit status and left a $1,000,000 endowment to support the perpetuation of Brookgreen Gardens.

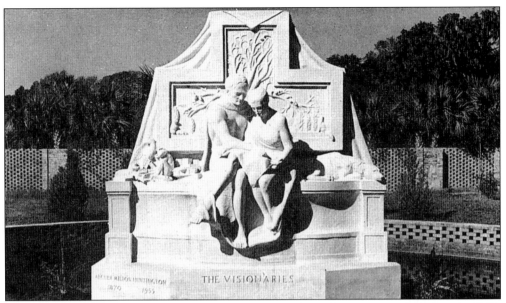

Archer Milton and Anna Hyatt Huntington purchased four adjoining rice plantations in 1930, with which to create their vision of an outdoor sculpture garden to display Mrs. Huntington's sculptures. Laurel Hill, Springfield, Brookgreen, and The Oaks Plantations sold for $225,000, with 6,635 acres, collectively. *The Visionaries* is Huntington's manifestation of their endeavor to create Brookgreen Gardens and was nearly completed in 1955 when Archer Huntington died. It remains a monument to the Huntingtons' foresight and generosity in establishing Brookgreen Gardens.

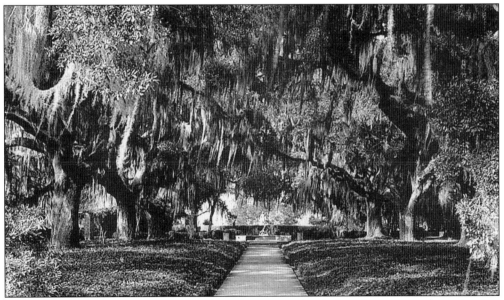

The pedestrian walkway leading beyond Brookgreen Gardens's formal entrance was previously a sunken road, worn down by centuries of traffic into Brookgreen Plantation. Its avenue of live oak trees is an entrance design duplicated on plantations throughout the South. The resulting canopy of moss-draped foliage grows more remarkable with each passing century.

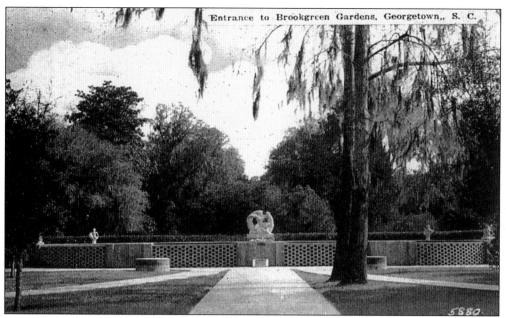

George Washington dined here in 1791. He was the guest of Brookgreen Plantation owner, Dr. Henry Collins Flagg and his wife, Rachel Moore Allston, widow of William Allston. Their house was located where this pool has been built. Remnants of the house's boxwood hedge remain as part of the gardens. This card was published by Iseman's Drug Store, Georgetown.

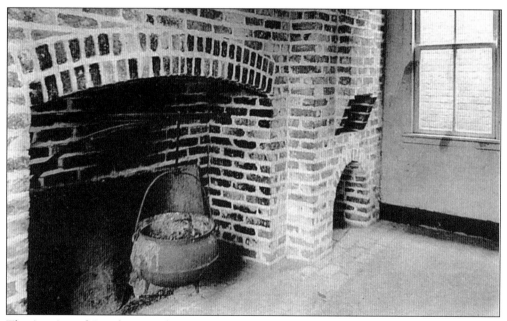

The interior of Brookgreen Plantation's separate kitchen building appears newly restored in this 1940s view. In the oversized fireplace hangs a cast iron pot, representative of the 19th century use of this building. During the construction of Brookgreen Gardens, this former kitchen served as a free medical clinic for workers and residents living nearby. An exterior view is shown, opposite.

a glimpse of Brookgreen which gives no idea of the extreme width of front. We are off to the mountaintop on the 11th

This card, postmarked Brookgreen, 1909, shows the house that replaced Brookgreen Plantation's 18th-century house, built by William Allston and enlarged by Joshua John Ward prior to burning in 1901. The former was the 1779 birthplace and childhood home of Washington Allston, famous American artist. Mrs. Louis C. Hasell, owner at the time of the fire, rebuilt this house on the original site. Used mainly as a hunting club, it was razed in 1931 during the creation of Brookgreen Gardens. (Courtesy of Burroughs and Chapin Company.)

This small building was the kitchen for Brookgreen Plantation. Originally situated 50 feet from the main house, it survived the 1901 fire that destroyed Brookgreen's main house. Now relocated, it offers refreshment to visitors at Brookgreen Gardens. The raised brick circle in the foreground of this 1940s view is a well.

This whimsical sculpture by Edith Barretto Parsons (1878–1956), entitled *Frog Baby*, is displayed in the pool of Brookgreen Museum's small sculpture court, encircled by a spray of water. Created in 1917, and shown in the 1940s, it depicts a joyous nude toddler, clasping a huge frog in each hand.

This was the site of Brookgreen Plantation's boat landing. The stately brick steps are considered antebellum construction, as newspapers dated 1857 and 1858 were found inside a column during repairs in 1930. Legend is that Theodosia Burr Alston, daughter of U.S. Vice President Aaron Burr and wife of S.C. Governor Joseph Alston, departed here on her final voyage in December 1812; more likely she left from the boat landing at her home, the Oaks Plantation, immediately south of Brookgreen Plantation. (Courtesy of Bill Benton.)

Night, sculpted in 1933 by Mario Korbel, was one of the first sculptures chosen for Brookgreen Gardens. It was placed beneath the live oaks to contrast with their shade. In 1954, Hurricane Hazel tossed a tree across the lap of this white marble figure of a reclining woman, missing her form by mere inches. Korbel's *Sonata* is also part of Brookgreen's collection. Korbel was born in Czechoslovakia in 1882 and died in 1954.

Boy and Fawn, by Gaetano Cercere, sculpted in bronze and placed in a setting of ferns and vines against a wall, symbolizes the youthful innocence of trust between child and animal, as the boy, standing over the fawn, offers a hand in friendship. Animals were Anna Hyatt Huntington's favorite theme; she included one in many of her sculptures.

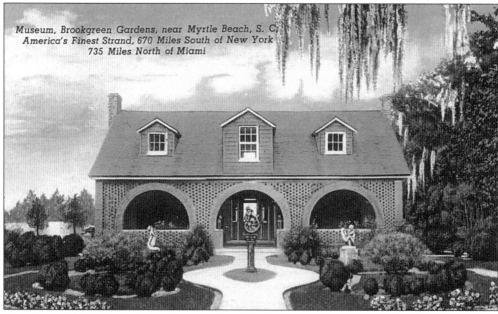

The entrance building to Brookgreen's Small Sculpture Gallery was in the 19th century the home of Brookgreen Plantation's overseer. Built near the main field ricefield overlook, it was moved in 1930 to the garden area and given a brick entrance foyer to coordinate with other garden features incorporating brick. The New York to Miami postcard reference was a 1940s advertising campaign persuading wealthy Northern tourists to stop at Myrtle Beach, instead of going to Miami.

The Christ Child, sculpted by Abram Belskie, was installed in 1936 with a blessing by the Reverend Henry deSaussaure Bull, rector of All Saints' Parish, Waccamaw Episcopal Church, at that time. Archer Huntington impulsively chose this piece upon seeing it, and it became the first of Belskie's work to be displayed publicly.

Don Quixote, by Anna Hyatt Huntington, was modeled at Atalaya, using a horse chosen for his decidedly poor condition. The animal required support to stand as the project began, but thrived on the attention received and made a remarkable recovery. Don Quixote was the hero of Cervantes' classic novel, titled by the same name.

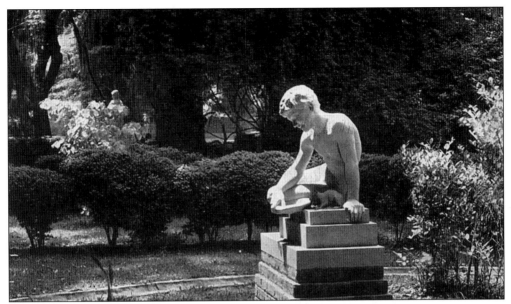

Boy and Squirrel by Walker Hancock was created in 1928 and originally located at the beginning of Live Oak Allee in a heart-shaped area. Sculptures in the gardens are periodically moved to accommodate new works and to create a fresh perspective on their individual qualities.

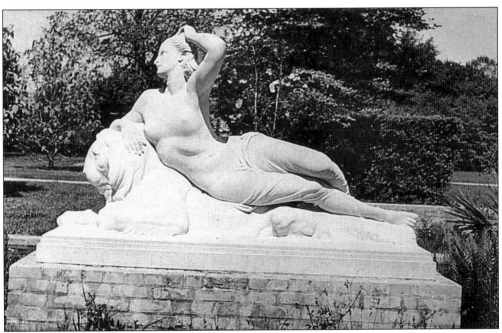

Nereid was created by Berthold Nebel, who had earlier been employed by Archer Huntington to create nine panels carved in limestone and symbolizing Spanish civilizations for the Hispanic Society of America, another Huntington endeavor. Huntington's philanthropy found numerous outlets, and he once remarked that wherever he put his foot down, "a museum sprang up." That foot, incidentally, wore a size 14 shoe. Huntington's wealth stemmed from his father's development of the Central Pacific and other railroads in the 1900s.

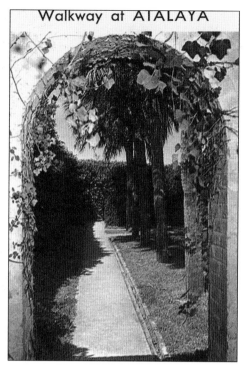

Walkway at ATALAYA

This is one of many enchanting walkways at Atalaya, a National Register of Historic Places site. Mature palmetto trees, palms, and creeping fig vines soften the extensive brickwork of this unusual residence, reminiscent of a fortress. It was here that sculptress Anna Hyatt Huntington continued her work as an artist, soon after she and her husband began spending winters here. Coincidentally, this castle is the site of an annual artists' sale, the Atalaya Arts and Crafts Festival.

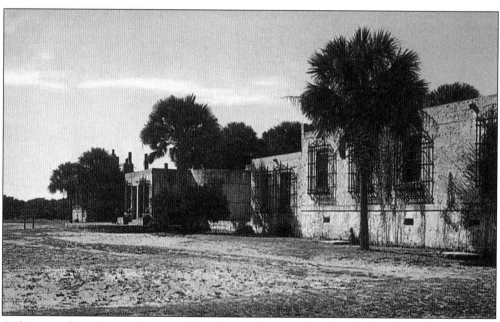

Atalaya was the winter residence of Brookgreen Gardens founders Archer M. and Anna Hyatt Huntington beginning in 1933. It contains over 30 rooms and was designed by Huntington with a central courtyard and Spanish-influenced architecture featuring distinctive "weeping mortar" masonry. During World War II, the U.S. Army Air Corps occupied this oceanfront castle to monitor the coast. Today, 1,500 acres of the Huntington's original purchase is leased to the state of South Carolina and operates as Huntington Beach State Park.

104

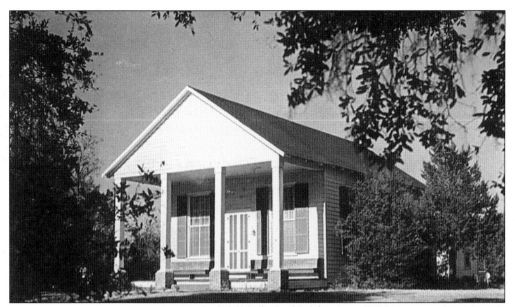

Belin Memorial Methodist Church was a mission church built at Oatland Plantation in 1835. It was dismantled and moved 10 miles to its Murrells Inlet site, beside Oliver's Lodge, in 1925, where it served this congregation until 1994. This church and its parsonage, below, have been replaced with modern facilities, but both older structures were relocated and continue to be used. Heaven Gate Church was the early Methodist church serving African Americans in Murrells Inlet.

This 1927 postcard depicts the *c.* 1836 Cedar Hill, former parsonage of Belin Methodist Church and originally belonging to Reverend James Lynch Belin, who bequeathed it and 100 acres to the Missionary Board of the S.C. Methodist Conference in 1859. It is Murrells Inlet's oldest building, and has been relocated beside the inlet.

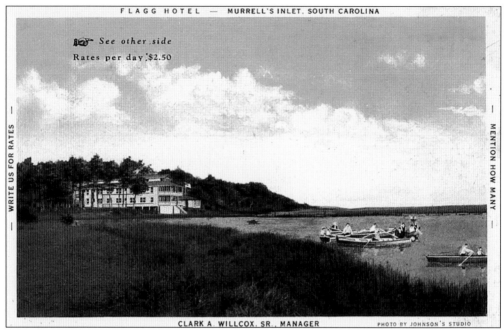

This 1926 postcard shows the Flagg Hotel, built around 1910 by Clarke Allen Wilcox Sr. Traffic in secluded Murrells Inlet in those days was slow; the hotel found business hosting Girl Scouts and Boy Scouts, and eventually converted to a youth camp, below. When this hotel was built, the local general store was named "Grab All." Competition arrived with a new general store, called "Take Some."

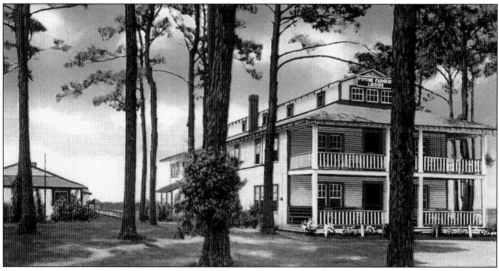

The Flagg Hotel, top, was converted to a Future Farmers of America camp in the late 1930s. F.F.A. is a national organization educating youths about agriculture, and this was one of three F.F.A. camps in South Carolina in 1940, when this postcard was published. The Flagg name originated locally with Dr. Henry C. Flagg of Brookgreen Plantation, who served on Nathanael Greene's staff during the American Revolution and hosted George Washington when he passed through the Waccamaw Neck.

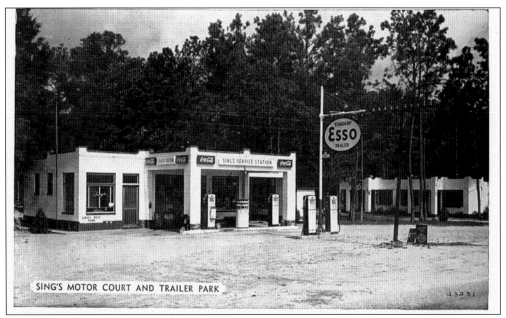

SING'S MOTOR COURT AND TRAILER PARK

Sing's Motor Court and Trailer Park was a 1940s tourist camp at Murrells Inlet, one of many that appeared along Highway 17 after it was paved in 1934. Alex Sing was a well driller, using a pair of mules for power; his sons, Alex and Tommy, were in the charter fishing boat business.

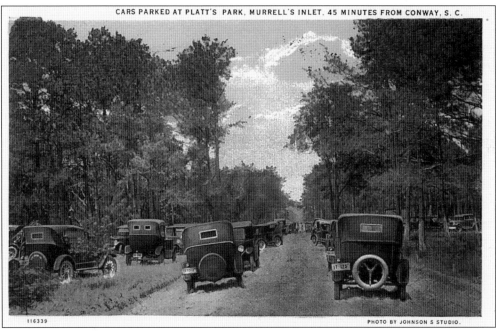

CARS PARKED AT PLATT'S PARK, MURRELL'S INLET, 45 MINUTES FROM CONWAY, S. C.

PHOTO BY JOHNSON S STUDIO.

Platt's Park, seen about 1926, was located west of Murrells Inlet's main channel and north of Laurel Hill Plantation. It was transected by Kings Highway, which was a dirt road then. Portions of this park belonged to B.W. Townsend of Red Springs, North Carolina, and Dr. V.F. Platt of Conway, whose business, Platt's Pharmacy, published this postcard. Earlier, the property was part of Laurel Hill Plantation.

The Hermitage, built *c.* 1849, was originally the summer home of Dr. Allard Belin Flagg who lived at Wachesaw Plantation. His sister, Alice Flagg, died here at age 16 and is immortalized as Murrells Inlet's legendary ghost. Located on a promontory of land wrapped with salt marsh, this Greek Revival cottage was part of the 937-acre tract, encompassing Wachesaw Plantation and extending from the Waccamaw River to present Garden City Beach, which Clarke A. Willcox Sr. purchased in 1910 for $10,200. In 1991, the Hermitage, part of a National Register of Historic Places district, was moved to a natural setting west of Highway 17 Business and renovated by Willcox heirs.

Murrells Inlet was a sleepy fishing village in 1927 when this image was made by Conway photographer Warren Johnson. The inlet's name derives from John Morrall, who owned 631 acres locally in 1731. The inlet has been a haven for writers; Pulitzer Prize winner Julia Peterkin, her daughter-in-law, Genevieve Chandler Peterkin, and the latter's mother, Genevieve Wilcox Chandler, all distinguished themselves by preserving in writing this area's heritage. Mickey Spillane is the inlet's most prolific writer, with his legendary Mike Hammer mystery series. Also, Clarke A. Wilcox Jr. wrote local history and folklore.

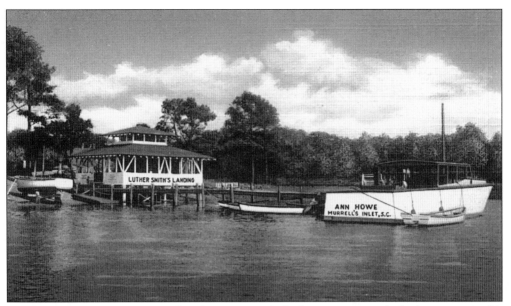

Luther Smith's Landing at Murrells Inlet is seen with the boat *Ann Howe* docked at its pier in this 1940s view of an early commercial boat landing. This is a classic representation of the inlet, whose residents over the past century have almost all been connected with the fishing and related seafood industries. Gulf Stream fishing, seafood restaurants, and the wholesale and retail seafood markets drive the economy of this growing area.

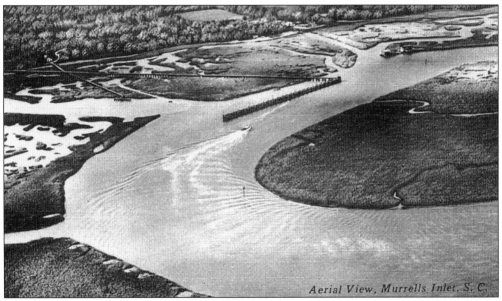

The most prominent feature in this late 1940s aerial view of Murrells Inlet is the government dock, built for the use of shore patrol boats during World War II. This is the vicinity of Drunken Jack Island, where the legendary pirate Blackbeard supposedly left a supply of stolen rum and a drunken crewman, Jack. Returning much too late, Blackbeard found only empty rum casks and Jack's scattered bones. The Hot and Hot Fish Club, an antebellum society of Waccamaw Neck planters, also started on Drunken Jack Island.

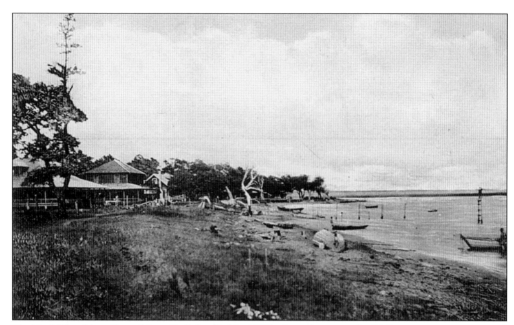

Entitled "Looking East, Murrells Inlet," this 1920 view shows early 20th-century cottages and wooden fishing boats as viewed from Woodland Landing. Woodland was the summer home of Dr. Edward Thomas Heriot, who lived on Sandy Island but owned plantations on the Sampit and Pee Dee Rivers before the Civil War. (Courtesy of Burroughs and Chapin Company.)

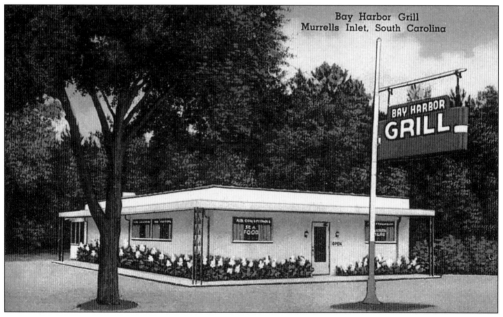

From the humble beginnings of Bay Harbor Restaurant, Oliver's Lodge, Wayside Restaurant, Lee's Inlet Kitchen, and Nance's Restaurant, Murrells Inlet has grown to claim the title "Seafood Capital of S.C.," with over 30 restaurants along its creek. A connecting waterfront Marshwalk showcases the inlet's marsh creeks, alive with wildlife and constantly changing with the shifting tides and the sun's movement.

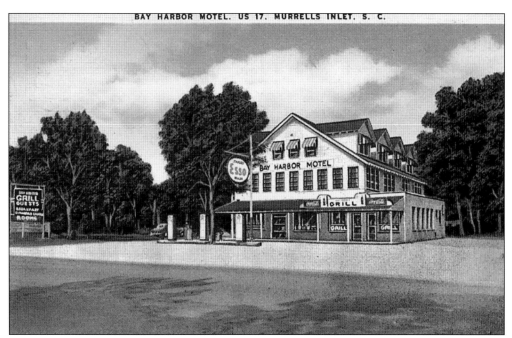

Bay Harbor Motel is shown in the 1940s, above, and a decade later, below, with its adjacent restaurant. This was the enterprise of Mr. and Mrs. Jimmie Eason. The Eason family has been associated with Murrells Inlet since 1917. Eason's Store was an early inlet general store. These two postcards, and the grill postcard, opposite, show the progression of Bay Harbor, from a boarding hotel with an inside restaurant, above, to the addition of an outside restaurant, lower left, to the dominance of the restaurant, below. Bay Harbor Restaurant outlived the motel where it started and was for decades an inlet landmark.

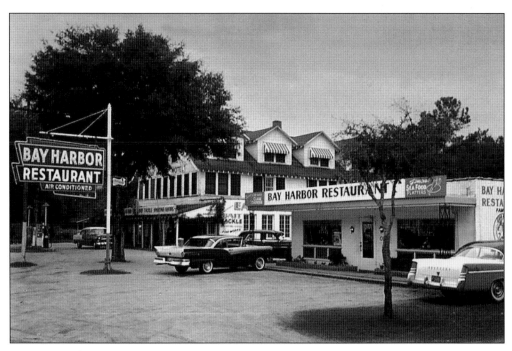

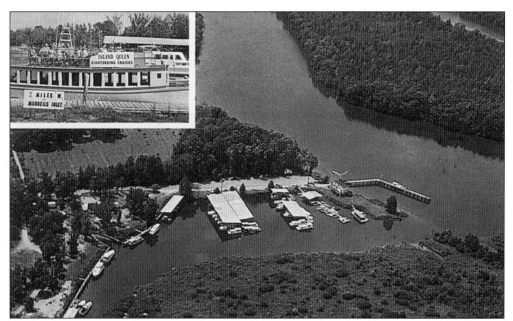

The area that Wacca Wache Marina occupies was previously Wachesaw Plantation rice fields, bordering the Waccamaw River, now part of the Intracoastal Waterway. Lawrence P. LaBruce developed this marina in the early 1960s, naming it by using the first two syllables of the words Waccamaw and Wachesaw. This was the home port of LaBruce's 41-foot *Island Queen I*, built *c.* 1939, which operated sightseeing cruises on the Waccamaw and Pee Dee Rivers until 1974, when *Island Queen II* was launched.

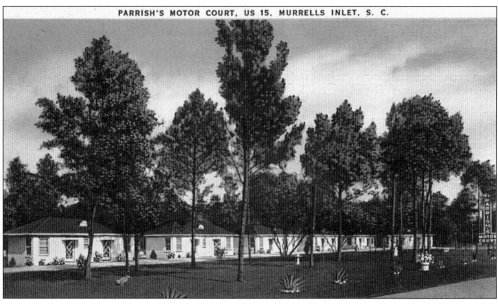

Parrish's Motor Court is now the Brookwood Inn, located on the south end of Highway 17 Business in Murrells Inlet. For over 50 years, this has been a popular accommodation for avid fishermen's annual trek to the inlet. Mr. and Mrs. R.E. Parrish were the owners when this 1940s postcard was published.

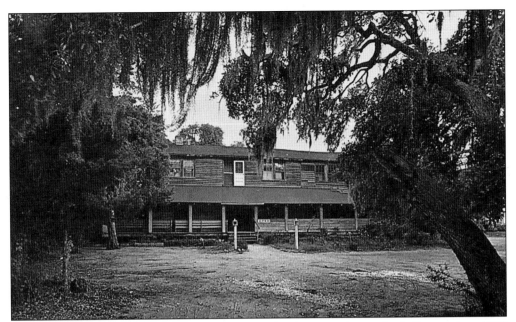

Oliver's Lodge, Murrells Inlet's oldest restaurant, has been serving seafood dinners since 1910 when Capt. Bill Oliver's catch was served fresh nightly. A fried seafood platter with hushpuppies is the classic dinner. Located beside Belin United Methodist Church on Highway 17 business, Oliver's was also a boarding house in its early days. Pictured in the early 1960s, it is still serving seafood favorites. (Courtesy of Burroughs and Chapin Company.)

Commercial and charter deep sea fishing is a Murrells Inlet industry started by Capt. Bill Oliver in the early 1900s. Here, the *Inlet Princess* returns to shore following a Gulf Stream fishing expedition. On the horizon is Garden City Beach, with only a few houses visible along a mile or more of coastline in this late 1950s view. Snapper fishing was this boat's advertised specialty.

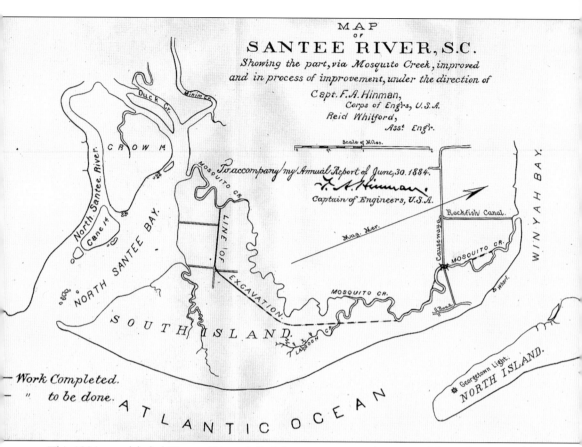

MAP
OF
SANTEE RIVER, S.C.
*Showing the part, via Mosquito Creek, improved
and in process of improvement, under the direction of*
Capt. F.A. Hinman,
Corps of Engrs, U.S.A.
Reid Whitford,
Asst Engr.

This 1884 map, labeled "Santee River, S.C.," focuses on excavations to straighten the route of the meandering Mosquito Creek from Winyah Bay to the North Santee Bay. This was a late 19th-century project of the U.S. Corps of Engineers, under the supervision of Capt. F.A. Hinman, and Reid Whitford, assistant. It was one of a series of engineering projects designed to improve maritime access to Georgetown. The areas shown on this map are within the Tom Yawkey Wildlife Center.

Three

THE SANTEE RIVERS

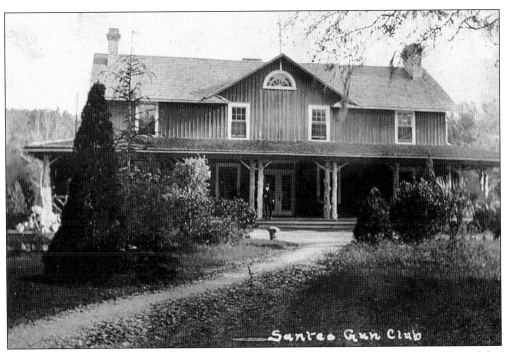

Santee Gun Club organized in 1898 with the purchase of 20,000 acres of the Santee River delta, including Murphy Island, previously belonging to a dozen rice plantations. Membership was restricted to 30 members. This rustic lodge, built *c.* 1905, is located near the South Santee River, east of Highway 17. Considered one of North America's best waterfowl hunting sites during its peak activity in the first half of the 20th century, this property is now maintained by the S.C. Department of Natural Resources as Santee Coastal Reserve. The card is postmarked 1911, from McClellanville. (Courtesy of Davie Beard.)

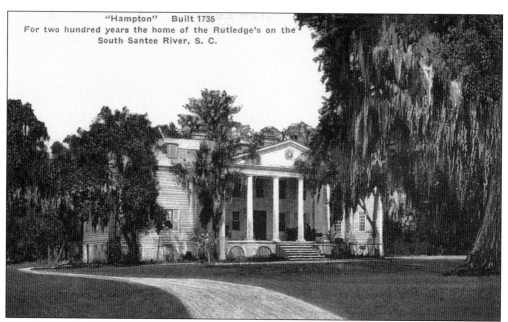

"Hampton" Built 1735
For two hundred years the home of the Rutledge's on the South Santee River, S. C.

President George Washington may be remembered for chopping down a cherry tree, but he did quite the opposite when visiting Hampton Plantation in 1791. Washington discouraged his hostesses, Mrs. Daniel Horry and her mother, Eliza Lucas Pinckney, from cutting the live oak tree, far right, that now bears his name. This plantation, built *c.* 1750, is a National Historic Landmark and a National Register of Historic Places site located 15 miles southwest of Georgetown and west of Highway 17. Its 322 acres are maintained by the state of South Carolina as Hampton Plantation State Park.

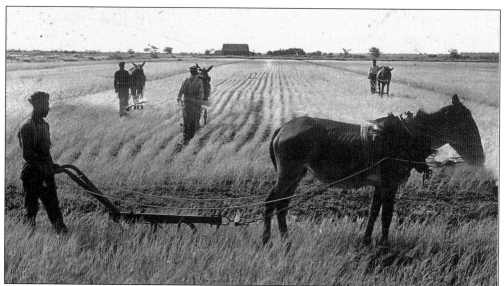

This 1904 stereoview depicts African Americans with mules plowing orderly rows through a broad expanse of rice fields. Several plantation buildings are visible across a river in the background. This South Carolina scene was typical of the Santee River delta a century ago, and it was probably photographed there.

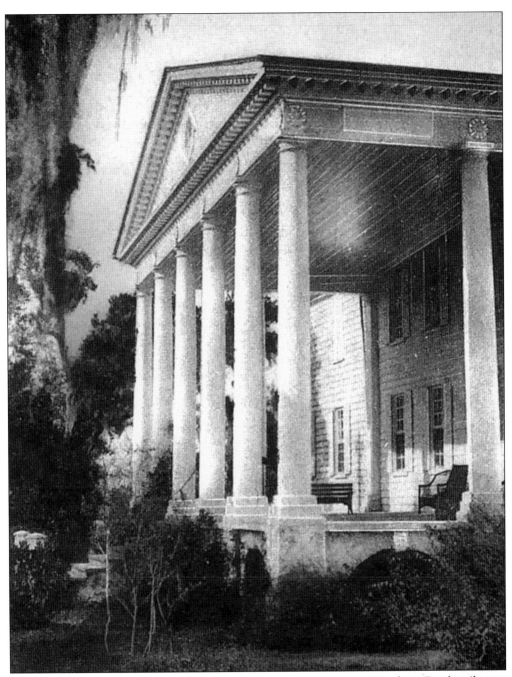

The stately elegance of Hampton Plantation's Georgian mansion on Wambaw Creek, tributary of the South Santee River, is best seen in its two-story Adam style portico facing the entrance road. For 200 years, this plantation was home to the distinguished Rutledge, Horry, and Pinckney families. The last of that lineage to occupy Hampton was Archibald Rutledge, prolific author and South Carolina's first poet laureate, who retired to his childhood home in 1937 and remained until his death in 1973. In his final years, Rutledge sold Hampton Plantation to the state of South Carolina.

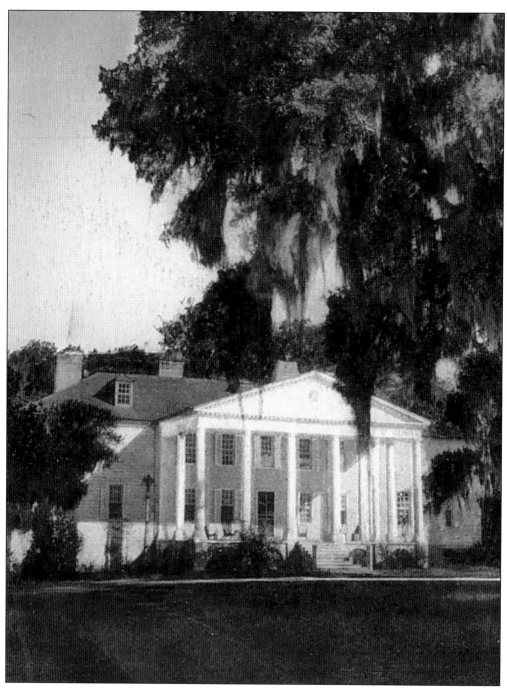

After the American Revolution, Hampton Plantation became the home of Eliza Lucas Pinckney, who moved in with her widowed daughter, Mrs. Daniel Horry, for the remainder of her life. Pinckney's successful cultivation of indigo brought financial wealth to the Georgetown region. Indigo grown on Black River plantations was of the highest quality. President George Washington was a pallbearer for Pinckney's funeral in 1793 at his own request, the result of a friendship forged when he visited Hampton Plantation two years earlier.

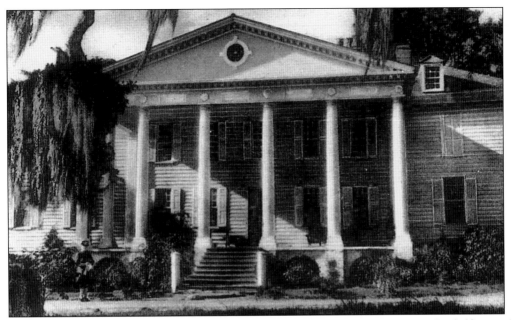

Hampton Plantation appears much grander than its modest beginning as a one-and-a-half-story, six-room farmhouse. Additions and renovations enabled the house to reflect its owners' growing affluence, most notably in the ballroom, with its two-story, domed ceiling and carved mantle with delft tile fireplace surround. The latter room alone established this as the premier residence, and thus family, of the French Santee.

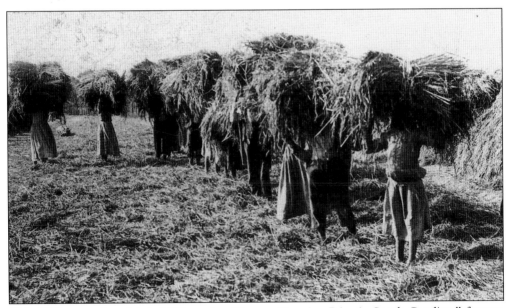

This 1895 stereoview, labeled "Plantation Negroes Carrying Rice in South Carolina," features African-American men and women indistinguishable for the huge bundles of rice straw carried on their heads. Rice straw was useful on the plantation as fodder and bedding. Prior to the Civil War, Georgetown County's population was 85% African American, the highest ratio in South Carolina; Charleston County's percentage was slightly lower.

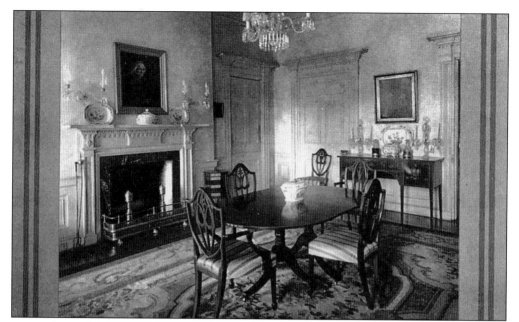

Due to family circumstances, Harrietta Plantation, begun in 1797 by the Horrys of nearby Hampton Plantation, was uninhabited until 1858, when Stephen D. Doar purchased it, made improvements, and occupied the house. The formal dining room in this 1930s view has intricate molding and an elegant mantle faced with marble. The door to the right of the fireplace is a dumb waiter that divides horizontally; its upper portion swings open to reveal graceful shelves used for serving from the pantry.

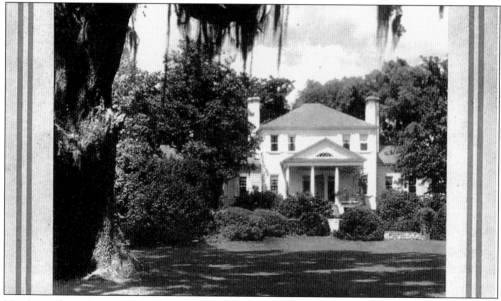

Harrietta Plantation, seen from the garden fronting its rice fields on the South Santee River, has an unusual triple door entrance with a false center door concealing an interior wall bisecting the house. Harrietta is a National Register of Historic Places site and thoughtfully designed, most likely by Thomas Pinckney of nearby Fairfield Plantation.

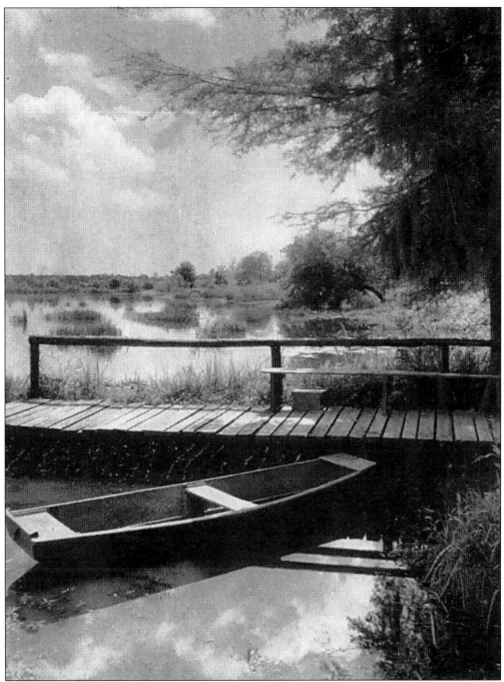

A small skiff awaits its owner in this picturesque view of Harrietta Plantation's rice fields on the South Santee River. Under the ownership of David Doar, a fifth generation rice planter, these rice fields were the last to grow rice on the Santee River and among the last in South Carolina to grow rice commercially. Following Doar's death in 1928, Harrietta was sold to Horatio G. Shonnard who restored the grounds and house, completing construction in rooms previously unfinished.

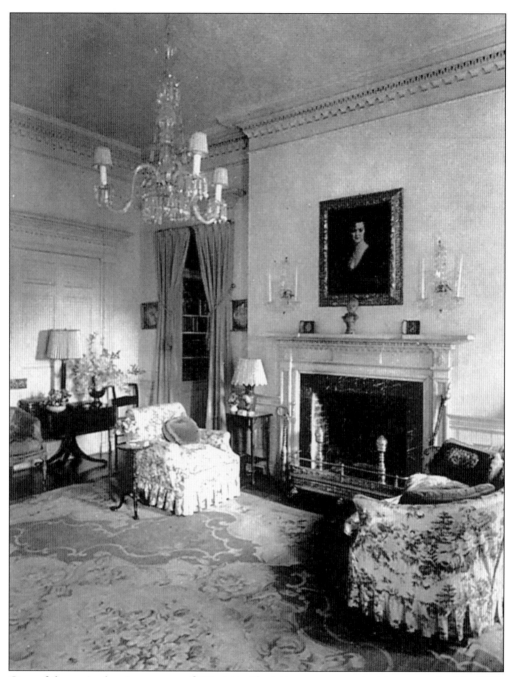

One of the main drawing rooms of Harrietta Plantation creates an inviting scene in this 1930s view, with period antiques and comfortable seating. Built of black cypress, this house exhibits symmetry and finely detailed woodwork. Both Federal and Greek Revival design elements are seen in its architecture.

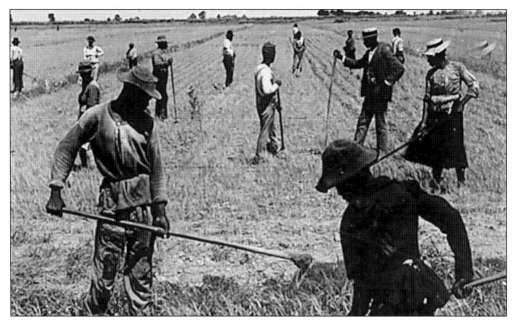

Over a dozen African Americans are working in a rice field in this 1915 stereoview entitled "Hoeing rice, South Carolina." Note the overseer on the right, wearing a suit and straw hat and carrying a walking stick. Alluvial deposits in the broad delta between the North and South Santee Rivers provided ideal soil for rice cultivation. Round, elevated brick hurricane houses were constructed on the delta and sheltered slaves in the event of a sudden storm.

Harrietta Plantation's south entrance was enhanced with this divided staircase during a 1930s renovation when this doorway became the house's main entry. Like many plantations, this house's main entry was reversed to face the land when water transportation declined. Harrietta has endured a succession of owners in the past 200 years, including periods of neglect followed by restoration. It still maintains its antebellum character, which has endeared it to all who have lived here.

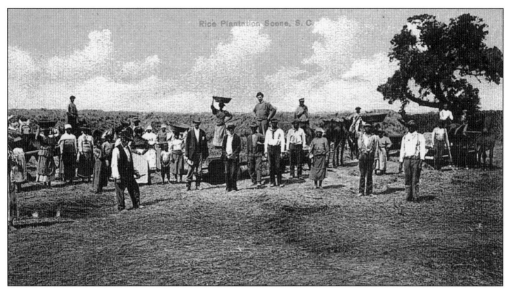

Entitled "Rice Plantation Scene, S.C.," this view depicts a group of African Americans assembled before a vast expanse of rice fields. Several of the workers have fanner baskets on their heads, used to separate the rice from its chaff, by winnowing. African basket technology, evidenced in Lowcountry sweetgrass baskets, has experienced a renaissance recently due to its growing acceptance as a Gullah art form. Originally a term to describe the unique language patterns of African Americans, the word "Gullah" now applies to a broader range of cultural traditions.

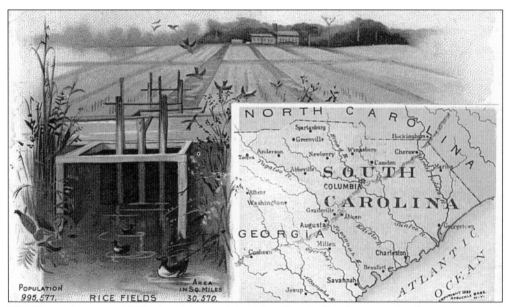

This illustration on an 1889 advertising card for Arbuckles Coffee shows a pair of trunk gates used to regulate the tidal flow of fresh water into adjacent rice fields. Gates were lowered after sufficient water flooded the fields on a rising tide and lifted on an ebb tide to drain the fields. Generally, four floodings were required to grow a rice crop: the "sprout water" to germinate the seed; the "point" water to strengthen the plants; the "long water" to float trash from fields, drown weeds, and kill insects; and the "layby" water to mature the crop.

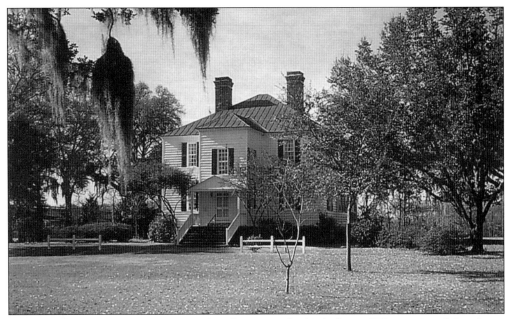

Hopsewee Plantation, built *c.* 1740, is best known as the birthplace of Thomas Lynch Jr., signer of the Declaration of Independence. Young Lynch and his father, Thomas Lynch Sr., were delegates to the Continental Congress, and the latter was also Winyah Indigo Society's first president. This National Register of Historic Places site is also a National Historic Landmark. Shown is the back of the house, with the North Santee River bridge visible on the left. (Courtesy of Raejean Beattie.)

An African American opens the trunk gate to one of many rice fields in this delta scene on an antique South Carolina stereoview. Rice fields were the migratory habitat of bobolinks, nicknamed "rice birds" due to their dietary preference for tender rice kernels during migratory flights. The persistent birds were both a scourge on rice plantations and a succulent food source for the planter's table. Local wholesale harvesting of the fattened birds spawned a profitable commercial industry, shipping processed birds to larger markets.

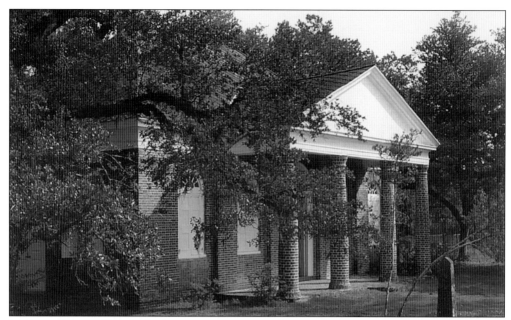

St. James Santee Church, built *c.* 1768, was also called Brick Church or Wambaw Church. It served French Huguenot and Anglican congregations of the French Santee, with separate entrance doors for each denomination. This church is located on the longest remaining unpaved section of old King's Highway, below the South Santee River and west of Highway 17. Similar floor tiles to those found in this church were identified on the site of Theodosia Burr Alston's Oaks Plantation at Brookgreen Gardens. (Courtesy of Emily Baldwin.)

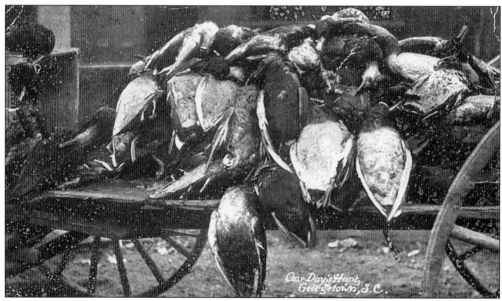

Ducks, and the opportunity to shoot at them, have contributed enormously to the economy of the areas featured in this book. They account for the sales of most Georgetown County rice plantations to wealthy Northern industrialists and twice brought President Grover Cleveland here to hunt with his friend, Confederate Brig. Gen. E.P. Alexander, who owned South Island.

126

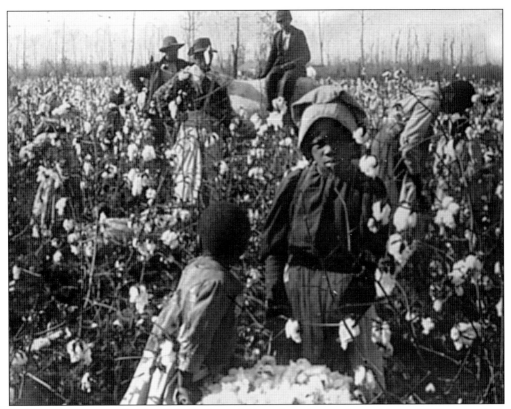

Picking cotton was a family affair for these African Americans, pictured in an 1899 stereoview. The younger children seem to disappear between the mature cotton plants. Can you find all nine people in this view? Cotton was rarely grown in Georgetown County until after the Civil War. In 1883, over a $1,000,000 worth of cotton was shipped from Georgetown's port, more than double the value of rice exported that year.

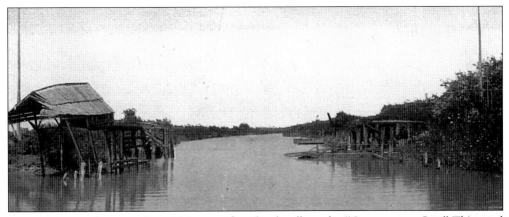

The Santee Canal, pictured in 1914, was referred to locally as the "Government Cut." This canal is now part of the Intracoastal Waterway's Maine to Florida route, linking Winyah Bay with the North Santee River via the former Estherville-Minim Creek Canal, dredged in the late 1890s. Congress authorized funds in 1919 to enlarge the canal to a depth of 10 feet and a bottom width of 90 feet. This was completed by 1936. An additional two feet of depth was authorized in 1937.

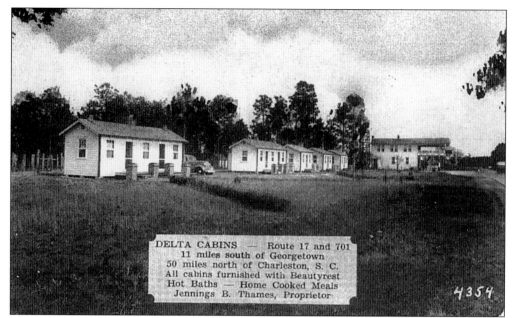

DELTA CABINS — Route 17 and 701
11 miles south of Georgetown
50 miles north of Charleston, S. C.
All cabins furnished with Beautyrest
Hot Baths — Home Cooked Meals
Jennings B. Thames, Proprietor

4354

This is a hand-colored view of Delta Cabins, once located in the Santee Community on Highway 17 near the North Santee River. Only the Delta Mercantile building, far right, remains today. It offered dining room service for cabin guests. This late 1930s tourist camp eventually included 26 units with private baths, steam heat, and electric fans. Porches were later added to the cabins seen here. Jennings B. Thames, Cecilia A. Thames, and C.T. Bruorton Jr. were listed on various postcards as owners of this lodging.

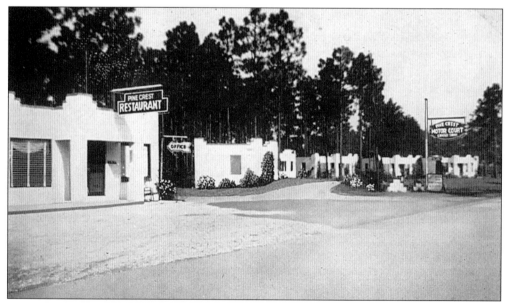

Located south of the Delta Cabins property was Pine Crest Motor Court, which included a gas station and a restaurant serving three meals daily. Now abandoned, these 1940s vintage cinder block cabins that were advertised as "100% fireproof" can still be seen on Highway 17 near the North Santee River.